HOME
Swell
HOME

DESIGNING YOUR DREAM PAD

OTHER BOOKS BY CYNTHIA ROWLEY AND ILENE ROSENZWEIG

SWELL: A Girl's Guide to the Good Life

COMING SOON

The Swell-Dressed Party

HOME Swell HOME

DESIGNING YOUR DREAM PAD

Cynthia Rowley and Ilene Rosenzweig

ATRIA BOOKS

New York London Toronto Sydney Singapore

ATRIA
BOOKS

1230 Avenue of the Americas
New York, NY 10020

ISBN: 0-7434-4277-6

First Atria Books hardcover printing August 2002

10 9 8 7 6 5 4 3 2 1

ATRIA BOOKS is a trademark of Simon & Schuster, Inc.

Printed in the U.S.A

For information regarding special discounts for bulk purchases,
please contact Simon & Schuster Special Sales at 1-800-456-6798
or business@simonandschuster.com

Photography: *pages 6–7, 12, 36, 60, 80, 96, 118, 138,* Sara Foldenauer;
pages 38–39, MapQuest; *pages 40, 146, 156, 167,* Charles Clower; *pages
43, 129,* Photofest; *pages 21, 31, 32, 52, 56, 67, 69, 80, 85, 109, 153,
162,* Photodisc; *page 54,* La-Z-Boy Incorporated; *page 88,* Weber-Stephen
Products Co.; *page 89,* Chuck Baker; *page 108,* Brett Lee/Starfile; *pages
40, 156, 167,* Charles Clower

Illustration: *endpapers and pages 17, 22, 26, 29, 44, 51, 55, 64, 71, 77,
83, 86–87, 90, 93, 98–99, 113, 133, 142, 155, 161, 165,* Ian Bilbey;
pages 6–7, 12, 36, 60, 80, 96, 114, 118, 138, 146, 150, 156, Chandler
Tuttle; *remaining illustrations,* Adam Chiu

ACKNOWLEDGMENTS

*W*e'd like to thank all the people who helped us build *Home Swell Home.* Our dream-pad dreamboat, Rick Marin. Our agent, David McCormick, who helped draw up the book's blueprints. Our tower-of-patience editrix, Greer Kessel Hendricks. Research darling Eleni Gage. Pallies Chris Calhoun, Ellen Tien, and Debra R., who helped spackle some holes in the prose. Jason Black, our expert contractor and reality check. And our first landlords—Joy, Alan, Barbara and Clementine, Ed and Carmela—who brought us up in happy eccentric homes that remain swell inspirations.

Contents

Swelcome Home

IF YOU DON'T HAVE A DREAM HOW YOU GONNA HAVE A DREAM PAD COME TRUE?

Time to redecorate. Clear the shelf of those fussy old shelter tomes celebrating sloppy-chic, delivering rhapsodic odes to the sofa and edicts about decorating a room one "important purchase" at a time. *Home Swell Home* has a new vision in mind. This book is about creating a dream pad; it's about exploring your design fantasies and learning how to make them real. It's a new set of style priorities:

KEEP IT SEXY

BREAK THE RULES

MAKE ROOM FOR FUN

EMBRACE IMPERFECTION

AND ALWAYS BE READY TO CHANGE EVERYTHING!

So, welcome to our humble book. A manual for the twenty-first-century home-owner (or renter) that demystifies design and shows how any house or apartment can be a place for high-style adventures.

How to give the place a sixty-minute makeover when romantic company's coming. Capture that vacation spirit right in your own backyard. A mix of know-how and inspiration, *Home Swell Home* is about overcoming the inhibitions that keep a girl from being the mistress of her domain: *Oh, I don't have a lot of money.*

Oh, I don't have enough time. Oh, I don't know what I'm doing. And, of course, *Oh, I'm not creative.*

While other books advise readers to be crafty (eucalyptus heart wreathes anyone?), *Home Swell Home* is a blueprint for the entire creative process, a guided tour of the ultimate Dream Pad. We begin in each room with how to turn on a light-bulb—that is, how to get your ideas and develop your eye, not just by what's on sale but by your own life: a movie set you love, a print from a happy-daze sundress, your new favorite hobby—scuba diving! All that silky black neoprene.

In each chapter, we offer a variety of "dreamscapes," a fantasy premise, followed by a description of how to put that look together. Some of our fantasies might not be what you'd expect to find in a traditional decorating book. But that's because a swell designophile remembers how to play house. Let the imagination run wild, and scale back later. Think of the house like you do your wardrobe. For some reason it's easier to splurge on a wild pair of thigh-high boots, or even a pair of big earrings for the big night, than on flokati pillows. Even though they're really equally disposable purchases. We want you to have the same derring-do at home.

Accompanying these floor plans are sidebars and short features that cover practical information: Furniture EMS; Five New Uses for… and Words from the Wise, which gives advice from a swell pantheon of style heroes, including Sister Parish, Hugh Hefner, Jackie Kennedy, Richard Neutra, and Diana Vreeland.

Here's where you learn all the stuff your gay uncle would have taught you, if only you'd known to ask: rearranging objects with asymmetrical balance, knowing what colors "advance" and what colors "retreat." And once you know the rules, you can ignore 'em.

We also share anecdotes of our own household hijinx to show that things go wrong, and *that's okay.*

In *Swell: A Girl's Guide to the Good Life*, we showed chicks on the go how to live

large without a lot of time and money. This Dream Pad Guide takes the Swell philosophy home. Think big. Make mistakes. Level the walls between high and low, disposable and permanent, traditional and modern.

A swell home is a place to accommodate a swell life—colorful, classy, cool, crazy, cheeky, chic. It's a place to indulge your passions. The key to a swell dwelling is to keep moving even if your address stays the same. As with any relationship, you want to prolong the infatuation phase with your dream pad by always making it feel brand new. To keep the fires stoked, you'll need plenty of ideas and inspiration—and someone to tell you how to open the flue.

SO, TAKE OFF YOUR COAT AND STAY A WHILE.

2

Feather Your Love Nest

A CHICK'S COOP HAS GOTTA HAVE SOME COCK-A-DOODLE-DO

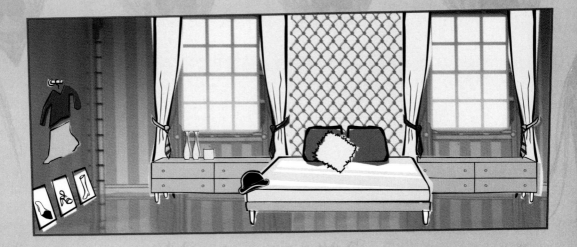

Lair du temps

You were expecting pastels and potpourri? Achoo!

When it comes to design, chicks often confuse sexy and feminine with girly and "romantic." Boudoirs exploding with chintz, cherubs, and china bowls of dried rose buds. For some reason, while the ladies have embraced the single guys' sexual independence and bravado, the men still got the lairs and girls work on their hair. While Marcia Brady was worrying about lemon juice highlights, Greg scored the attic and put up love beads. It's time to liberate our libidinal love shack.

Remember how all those bachelor pads in old movies had a touch of James Bond? Hit a button and the lights dimmed, the mood stereo turned on. Rewind a few videos in your memory banks. In Rock Hudson's playboy playpen in *Pillow Talk,* he flipped a switch to make the couch pop open and the door lock. Peter Sellers had a crafty cad pad in *There's a Girl in My Soup,* where he played a galloping gourmet hungry for Goldie Hawn. The covers lifted off his rotating round bed by a velvet rope as if unveiling a four-star entrée. What bedroom scenes got you excited as a kid? *I Dream of Jeannie*'s studio in a bottle? Embrace romantic comedies. Swell sex appeal doesn't have to be so serious.

Maybe hotels fire you up or sleeping under the stars. Or the mad flush of excitement you only experience shopping for new clothes. Sometimes all you need is to try some new positions for the bed, dresser, and nightstand. Only you know what forbidden fantasies or indulgences get your blood pumping. But here are seven deadly bedrooms to get you to Inspiration Point.

Elements of a *Bomb* shell-ter

When trying to dress like a hottie, you don't mummify yourself in frilly florals and prim lace. You cut the froufrou with booty-hugging jeans, a slipping-off-the-shoulder gown. Apply the same foxy logic when designing your bombshell-ter.

The kaboom countdown:

10> Revel in anything revealing: *Sheer is suggestive, see-through provocative. Lucite chairs, a scrim to change behind, a wall of glass blocks, like the one in the Glass House in Paris built by the French modernist architect Pierre Chareau.*

9> Cut-outs: *A keyhole neckline makes the mercury rise. Same with a peekaboo hole in the bedroom wall, high enough so you have to climb up to see out and too high to see in. In Japanese love hotels, where young couples rendezvous, the bedspreads have wide circular cutouts that show the sheets underneath.*

8 > Cutoffs: *A Daisy Dukes denim bedskirt, with the hem snipped off and frayed.*

7> Contrast hard and soft: *The old leather-and-lace trope still holds. Like Pinky Tuscadero and the Suedes on* Happy Days. *Buttah up the leather couch with soft, pink mohair pillows.*

6> A girly glimpse: *Lacey anklets twisted with a pair of high-heel sandals. Pull back the grown-up bedding to uncover your Scooby-Doo sheets.*

5> A manly touch: *Liza in her garters and bowler hat in* Cabaret. *Use men's ties to tie back the curtains; toss the bowler hat on the bedpost.*

4> Curves! *Vases, arches, the well-rounded back of a couch. Old movie sirens posed for glamour shots on silk settees whose shiny upholstery was stretched as tightly as their body-hugging satin sheath gowns.*

3> She's come undone: *Some décor décolletage. Hang curtains that button open and close, make the bed wrong.*

2> Sparkle: *It's elemental, shiny things attract. Put some flash in your foxhole. A tiara swinging from the headboard.*

1> Something wild: *Take a few cues from Ginger on* Gilligan's Island. *Even with desert-island resources she had a knack for hottifying the hut. Leave something unfinished, unvarnished: paint splotches on the floor peeking out of a pretty fluffy rug; wallpaper that didn't scrape off and fresh flowers from the other side of the island.*

Scheme 1 | James Bond-Age

Dream

Tipsy from champagne and chemin-de-fer, you're making eyes at a devastatingly deadly fellow spy. You collect your winnings and ask, "One more roll?" Together you repair to Suite #008, a mod playpen with the Monte Carlo skyline twinkling in his eyes.

"Nice outfit you're almost wearing," he says, as you emerge from behind French doors that swing open magically like the ones at the A&P.

You pull a book on the shelf and the library wall drops to reveal a bar chilling with Dom Perignon '53.

"My favorite," he says, switching glasses. He's dangerous, irresistible, you think, as he carries you up the shag-covered steps to your waterbed on a Lucite platform filled with shimmering piranha and asks, "Which side do you prefer?"

There's only one reply: "Yours, of course."

Reality

Who cares if Dr. No blows up the world? You'd be the evil genius' love slave just to steal a few secrets from his volcano hideaway. And why not? Even Sean Connery with hair isn't as seductive as the futuristic vibe and air of mod mystery of the bedroom sets in those Bond films. It's a male fantasy of cool elegance: minimalist and masculine—with a soft, plush core. Here's a prescription from Dr. No-No.

Everything is hidden, so you don't give anything away about yourself. Only the bed is in plain view—a big, round, satin-sheeted centerpiece heaped with Siberian goose-down-filled pillows and a fur throw, stitched together from Grandmama's cache. If the bed is sensuous, the rest of the room must be as cool and reserved

as a Russian double agent. Minimal furniture. And creamy, deep-pile, wall-to-wall carpeting (so no one can hear you sneaking out, or in). Even the furniture has secrets: built-in consoles that push open to reveal refrigerated interiors. Sub-Zero makes refrigerated cabinets with different facades for the kitchen. And there's no law against putting them in the bedroom to store caviar, single-shot bottles of Stoli, and lingerie in summer. (Though a hidden mini-mini bar will do.) A two-way mirror for the walk-in closet door, to eye-spy him while you're slipping into something more comfortable. Hack into cornerspyshop.com for a few extra tricky trinkets: an ashtray transmitter, video-camera pen. On the bedside table is a briefcase. *Is something ringing?* Pop it open and answer the phone. "Sorry, gotta go." New assignment.

SO BAD IT'S GOOD: *Round Beds*

Circular Logic:
A Brief History of the Round Bed

When did people develop such square notions about round beds? Before they were associated with cheeseball honeymoon hideaways in the Poconos, round beds were considered sophisticated, high-class, worldly. Swear. In Top Hat, Fred Astaire and Ginger Rogers dance in circles around each other in cases of mistaken identity, in and out of the Italian resort's super-swanky bridal suite, with a giant satin round bed always looming in the background like a full moon of temptation. In the fifties, the round bed was the backdrop for starlets doing publicity photos, preferably with, as Jayne Mansfield posed, a halfshell headboard. Elvis kept a white round bed at Graceland. Hugh Hefner had an infamous rotating one on his plane that was covered in Tasmanian opossum pelts. Maybe that was the turning point. But what goes around comes around. They're back, but in a sense haven't they always been...around? Nowadays, round beds can be found by visiting www.sleepcare.com (yes, heart-shaped mattresses are available), or dial 516.868.5400 for Sleepcare, Inc., the company that asks the question, Why stick to geometric shapes? One swell egg had a mattress and box spring fashioned in the silhouette of the state of Illinois. **Psst:** birthday present for Cynthia?

Scheme 2 | *Some Like It Nude*

Dream

When asked what she likes to wear to bed, Marilyn Monroe famously said, "Chanel No. 5." Va-va-va room! Your bombshell-ter will be a honey of a room that whispers all its lines, and dares to expose its vulnerable side.

Reality

Go all the way. Paint the room nude—the color, that is. Paint stores boast they can match any shade you bring in. Make the salesclerk blush by flashing some gam and asking him to mix a bucket in your flesh tone. En route home, a lightbulb goes off: Shimmer! Like the Barbie glitter you put on your shoulders when you've got a tan. Sprinkle craft-store glitter into the paint can and start rolling. Oops. The glitter wall has no sparkle, just gritty bumps like hives. Not sexy.

Do-over. This time, research turns up that Crayola makes sparkle glazes. Paint the three unruined walls and cover up the mistake wall with…something to downplay the glitter…ultrasuede upholstery! Call it a "bedhead wall," what swanky hotels use instead of headboards to create a cocoon vibe and muffle noise. Staple up some foam and nail fabric to the wall with upholstery tacks. Hammer in some leftover nails for fun in the shape of a horseshoe. Get lucky, get it?

Now the floors. Strip 'em! While you're at it, strip the dressers, too! The rough textures are as stimulating as making out with your stubble-faced carpenter. Seem kind of bare? Lay a bearskin rug on the floor, a bottle of Marilyn's fabled fragrance on the vanity, and fill a wall with your budding collection of nude oil paintings. Even if it's only a collection of one. Hang it over the vanity—no, not there, a little off to the right. Always pin up pictures slightly off-center and lower than you think. Galleries hang them at eye level—and not Shaq's eye. Uh oh: drywall disaster. Cover up the bad hole with toothpaste. Really big hammer disaster? Grab a keyhole saw and cut the hole bigger. Call it your peekaboo cutout!

19

Dressing the Bed

People are more monogamous with their bedding than to the guys sleeping under it. What a sham! A little infidelity in the linen closet can go a long way. Buy two or three sets of sheets that work together—a print, a stripe, a solid; one lighter, one darker, one more daring—and mix them up. Change the combos every laundry day.

Ask Swelloise

How to Get Paint Out of Your Hair: Jump in the shower. Most room paints are latex, which is water-based, so it'll wash out immediately—if the paint is still wet. Wait till it dries and you'll have to go through several hair washings and scrapings to get the flakes out.

You don't dress yourself in matchy-matchy ensembles; why make the bed look so uptight? Mess up somethin'. Have a pillow fight and break up the symmetry, the tyranny of blue-blue, plaid-plaid, fruity accent bolster. Alternate the patterns, turn some vertical, and throw in a curve throw. Anything can be used for a bedspread. Fill the trousseau trunk with: a beach towel quilt for summer; a bedspread of coats sewn together for the chalet months; a taffeta coverlet and a twin set of cashmere pillows with mother-of-pearl buttons; a vintage flower power tablecloth you have stitched onto the plain duvet cover, dee-liteful for breakfasts in bed; a blanket customized with a patchwork of old pashminas that you don't have the heart to give away.

A bit of BEDLAM in the bedroom will look intentional if, at the end of the day, it's all pulled together. Just be sure the bed looks neat and inviting. Rumpled sheets are only sexy after the fact. Here, a few tricks to make that crib look like virgin terrain.

INSP ECTION

Police cadets **SPRITZ WATER** on the sheets so they dry tighter enough to bounce a quarter off.

Smooth magazine stylists **IRON THE SHEETS**—after the bed's made.

HOSPITAL CORNERS. Orderlies make the bed look as nifty as a well-wrapped present. Tuck the sheet in at the foot of the bed, lift the dangling piece on the side, tuck in any sloppy bit of sheet remaining, drop the end, and tuck that, too.

SHORT-SHEETING: Why go to sleep angry? Make pranks, not war. Think of making the bed in reverse: Tuck the top sheet in at the head of the bed, fold the loose end up to where the pillows go. Lay down a blanket, just like normal, fold the top sheet down, and tuck it all in—just like normal.

Word from the Wise: *Eleanor Lambert*

Walls That Keep on Ticking: *Upholstered walls do not have to be expensive damask to be elegant and enduring. Eleanor Lambert, legendary fashion publicist who created the Best-Dressed List, covered the walls in the bedroom and bathroom of her Fifth Avenue apartment with blue-and-white mattress ticking. "I got it for a dollar a yard from Geoffrey Beene," she told* The New York Times. *"He had decided not to use it, and had bolts of it." The nonagenarian kept them that way for forty years, and though they were faded from sun, stained from steam, and "the effluvia of forty years," the* Times's *fashion critic pronounced them to be still, inexplicably, beautiful. Keep in mind, horizontal stripes make a room look wider. Vertical stripes make it seem taller.*

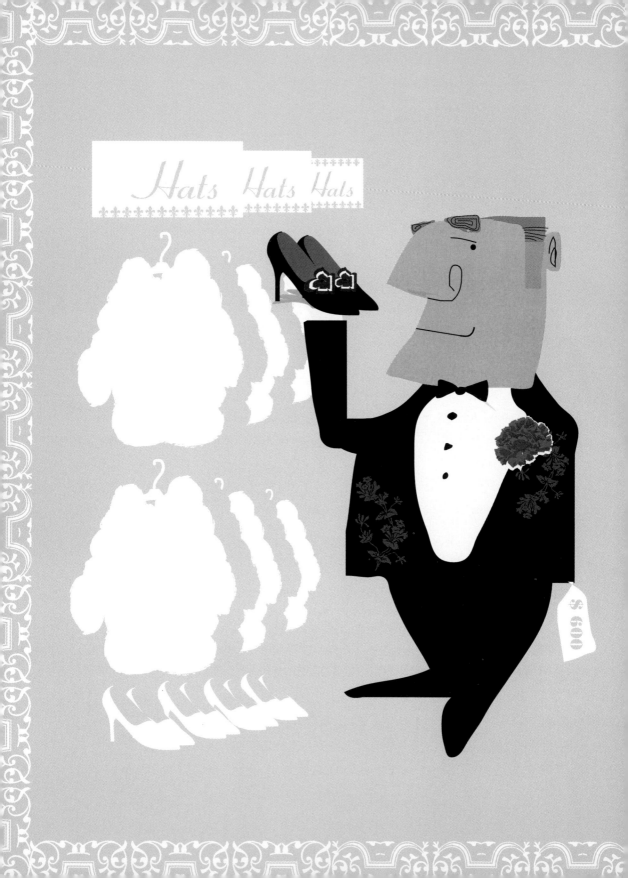

Scheme 3 | I Can Get It for You Retail

Dream

Furniture? Who can find it? The chairs are just a poor excuse for hangers. You haven't seen the carpet next to your bed in years. If only you had more closet space, your room wouldn't look like a bus stop on Oscar Madison Avenue.

Reality

Bring the closet out of the closet! Rethink the bedroom with retail design strategy: The more frocks, bags, and bijoux you can see, the better. The goal is to have the merch look as good as it does in one of those boutiques redolent with the pulse-racing scent of burning plastic.

Let our floorwalker, Mr. Merriwether, show you around the store. You might remember him from *The Lucy Show.* That's him over there in the supercilious bow tie.

"Mmmmyess?"

"Well, sir, I normally lay my outfits out on the bed—"

"—*No no no no no,* Madame. Hang them on 'look hooks.' The little rods that pop out of the wall? Called 'face outs' in the garment biz? Oh, *dearrr.* Put one 'look hook' at shoulder height for shirts and jackets, another at waist level for skirts and trousers. Now, a shelf off to the side to hold a handbag, jewelry and other accessories. Empty the bookcase of those dusty *books.* Stock it with *shoes* and *bags* mixed in with a few *objets* of interest. Those black, silky fifties pumps, put them next to the red curvy vase, the red one. Ooooh yyyyes, delicious. *Un*hand my photo of Ava Gardner.

"Excuuuse me, Madame. Keep a few retail concepts in mind: Neeever show more than one season at a time. The current season gets shown by color on rrrrolling rrrracks. We purchase ours from a retail supply company. Don't cram them all together. Where do you think we *are,* the rummage rack at *Loehmann's?* Allow an inch between hangers, the clothes have to *breathe.*

"Set up a 'dressing area' that makes you think, Buying new clothes! instead of, Trying to get dressed for work! A few touches to make the ladies happy: a three-paneled mirror, a Velveteen curtain to change behind, a patch of carpeting for stockinged feet. On the other side of the curtain goes what I call an "audience chair" for any *Pretty Woman* moments.

"Now then, the lighting in the dressing room. Fluorescent is verboten. We prefer natural-looking overhead light on a dimmer switch to simulate daylight and eeevening. It can be cranked up all the way to check for see-throughness or otherwise unsightly sights. Speaking of which, help me carry off this clunky dresser. For scarves and sunglasses and hair combs, we'll order a full-vision glass showcase from displaywarehouse.com; oh, and maybe a black velvet jewelry display.

"Mmmmyess, Madame? Oooooh, do we have pea green sweaters!? Stacked up right here on these acrylic risers. Oh, and there's only one thing wrong with your credit card, Mrs. Carmichael...it's no damn gooood."

How to Fold a Sweater Like a Gap Pro

Lay the sweater front side down. Position an eight-by-eleven-inch piece of cardboard with the short edge centered on the sweater collar. **Fold** the left side of the sweater over the cardboard, then fold the left sleeve back over itself. Repeat on the right side.

Using the bottom edge of the cardboard as a guide, fold up the lower portion of the sweater and the sleeves. **Flip** over the sweater, gently slide out the cardboard, and get it back out on the sales floor!

Scheme 4 | *Let's Make Camp*

Dream

Some folks flip for the fresh roses and turndown service of a Relais & Chateaux hotel, but your idea of touch-me-I'm-tingling, four-star luxury is sleeping under the Big Dipper.

Reality

Kids know you don't have to be 300 miles from a shower on the Appalachian Trail to get into the camping-out spirit. They pitch tents in the backyard or between bunk beds. For grown-ups there's safari sophisticated—mahogany and mosquito netting. But it doesn't all have to be so "I had a bedroom in Africa..." What about good old KOA, Kampgrounds of America? Bring back the bucolic thrill of those great nights roughing it and roasting marshmallows with the rest of the Girl Scouts.

Set up camp by wedging a low wood platform bed in the corner of your room and pitching a "tent canopy." Screw a couple of hooks into the ceiling and suspend a pup tent the size of your bed from the ceiling so that the tent floor rests on top of the platform, then slide in your mattress. Roll back the door flaps and window flaps. Inside go crisp white sheets, an army blanket, and an unzipped sleeping-bag comforter. A couple more essentials for the packing list: a flashlight for the bedside table, in case you get scared and Audubon drawings on the wall of yellow-bellied sapsuckers and other birds worth sighting. Outside the tent goes a "campaign" desk, like the kind Napoleon designed for himself because he wanted to be on the battlefield surrounded by familiar, comfortable furniture. His were collapsible, like a card table, and fit into special trunks for easy transportation. Here's where you write postcards or fill in your diary with your own war stories.

Set up a couple of natural canvas camp stools and a sawed-off log ring side up to hold your campfire song book, a bowl of marshmallows and a bugle to blow taps when it's time to turn off the Nature Channel.

25

Scheme 5 | *Wicker Is Quicker*

Dream

Just cashed out and bought yourself the summer cottage of your dreams. Push open the bedroom door and find the previous owners happen to have left behind a room full of... wicker. Ugh. All that brown, faded, boring old stuff that looked like it belonged to Muffy on the field hockey team who spoke in initials: ATD (absolutely to die); PTH (peak tanning hours), and such. Remember that old *SNL* (Saturday Night Live) sketch about the "all-night wicker store?" Maybe you could make wicker funny, too.

Craft Single

Monogram or customize sheets and pillowcases. Where? Ask the tailor—if he doesn't do it, he'll know someone who does. Transcend your initial thoughts. The monogram place can do anything with three or four letters: HIS and HERS; MOM and DAD; ZZZ (BOW and WOW for your puppy Peachy McBellicot's bed). You can also embroider your own monogram, or stencil it on with a Laundry Marker to make your standard-issue sheets special enough for Private Benjamin's cot.

Reality Tear out a page from *The Preppy Handbook.* Drag your heirloom wicker out back and spraypaint the whole set lime green, one of those WASP shades Tom Wolfe called "go-to-hell colors." Don't worry about being too loud, this is a TDC (total design concept). Then mix up a batch of G&Ts, and—what were we doing again? Oh, right, paint one wall shocking pink, then leave the rest a tasteful debutante white. Chintz is so SOT (same old thing). Find a "simply super" fabric: white with oversize strawberries. Go mad for it and cover everything from the bay window seat to the curtains. OTW (off the wall)! With complementing candy stripe on the valance.* Mummy's ottoman? Gotta keep it. Re-cover it with a giant ladybug button-on cover. With the dark wood base it looks like an overgrown Bermuda bag. Yummy. Stick some postcards of Bermuda in the mirror. The bed is a spray of pillows: toile de Jouy and needlepoint ones with messages (No PDA). Would you pass me that clamshell ashtray, Lovie? And monograms, monograms, monograms. A clock hanging from a grosgrain striped ribbon. The floor is pickled white, just like Uncle Trip. CBC (couldn't be cuter).

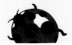

✳ CRIB NOTE

What the heck is a valance? A short drapery or facing of wood across the top of a window, concealing curtain rods, etc. They're supposed to enhance the illusion of height.

SKYLIGHT ALTERNATIVES

Things are looking up. Most of the time you spend in your bedroom you're horizontal, yet the ceiling is so often overlooked. Heavens, you don't have to be Michelangelo to have a few ideas for overhead attractions.

ZODIAC

Paint Pisces, Leo and your other compatible signs in silver leaf in homage to the ceiling at Grand Central Station.

MODEL AIRPLANES

Dangle planes, rockets, and other boy toys, like the ones hanging from the barroom ceiling at New York's legendary '21' Club.

TRAVEL POSTERS

Paper the ceiling with tourist board ads of faraway places you dream of going to—sigh—someday.

FLYING BIRDS

A flock of photos of soaring birds. When you go to bed feeling like the world just doesn't understand you, think of Jonathan Livingston Seagull and have a breakthrough: "I am a perfect unlimited gull."

Scheme 6 | *This Is Not a Bedroom*

Reality Surrealism was an artistic and literary movement devoted to capturing dreams. René Magritte, Salvador Dalí, Hans Arp, André Breton all aimed to tap into the unconscious and translate its pure wild imaginings directly onto the canvas or page without the filter of the conscious mind. To free themselves from reason, they did crazy things. They painted eyeballs with skies in them and melting clocks, made collages of torn paper arranged according to the laws of chance. They carried the dream into waking life with pranks and grandiose proclamations: "Dalí is the greatest painter who ever lived!" Salvador Dalí would say, walking down the street with a Mohawk hairdo and a lobster on a leash. Marcel Duchamp seems almost normal by comparison, exhibiting a signed snow shovel in an art gallery and "improving" a Mona Lisa by painting a mustache on her. As Breton wrote, "The approval of the public must be avoided above all." Free yourself from logic. Blur the lines in your bedroom between dream and reality.

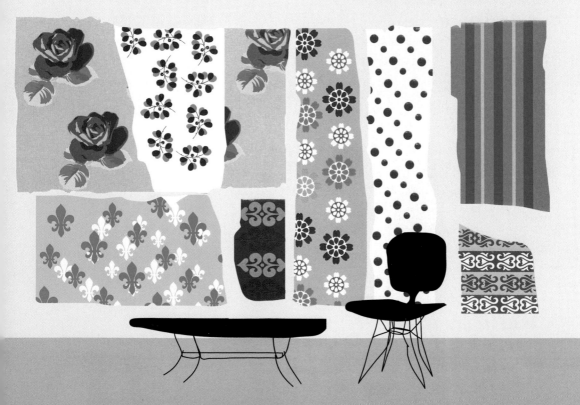

Dream

I was in this room, and it was my room, only it wasn't. The bed was very, very tall, stacked high with mattresses, like in The Princess and the Pea. And then I said, "Only bad thing is if you have to pee!" So I put a step ladder at the foot of the bed to climb up and decided to dress it with a taffeta ballgown bedskirt, and a pair of winking eye pillows (one painted with the outline of an open eye, the other with a closed one). The bedside table was a stack of books as tall as the bed, old bedtime classics: Little Women, The Secret Garden, Moonstruck Madness, that I'd bought somewhere. To keep them together, I drilled a hole through each copy and stuck a really long dowel through them. Do you think that's sexual? Then the dream switched and I was looking at wallpapers, unable to choose a color. The back of the paper said: "Court the muse of chance." And I started tearing up the wallpaper in interesting shapes and pasted the pieces on the wall in my own design so it looked really beautiful. Then I thought I heard music, like a Dvorak symphony, but it was just a cello leaning against the wall and beside it one of those small white title cards they have at museums that read Nude Opus #1. I think that was definitely sexual. There was something about a fur teacup. I see a window way up high, though I'm not sure if it's a real window or just a painting of a window, and I want to climb up to it, because I think that at the top of the stares, I mean stairs, will be a peephole, and if I look through the peephole I will see the word Yes. That was the installation that Yoko Ono did when John Lennon fell in love with her. Oh, then I notice a shelf with a vase full of brilliant orange poppies and behind it a pencil sketch of the flowers, which I go to smell and it smells just like Andree, my old friend from Paris who wore Opium perfume, and then suddenly I feel really sleee—

Reality

Nobody really wants to hear other people's dreams.

SO BAD IT'S GOOD: *Bedskirts*

In the 1860s, the same code of Victorian prudery that segregated books on their shelves by the author's sex enforced the covering of the legs of beds with crinoline skirts. But the skirts could be de-prigged with the right fabric, say, fetching fishnet, or rhinestone-studded denim, a naughty lace that matches your casually cast-off nightie.

Anything can be a...*Headboard*

It's just meant to focus the eye and prop you up.

Bubble-Wrapped *headboard...with a padded movers blanket.*

Flower headboard... *like a Rose Bowl float. Styrofoam with flowers tucked in.*

Horseshoes... *and horseblankets. Giddyap.*

Colored lights... *tacked up to the wall...and an electric blanket. (Turn to your dreamboat and quote a line from* A Streetcar Named Desire *when Stanley says to Blanche, "Let's get those colored lights going.")*

Scheme 7 | *Bamboo Bungalow*

Dream

Walking through Chinatown on the way to a pedicure, we two swell girls noticed how all the Korean grocers were selling little stalks of bamboo, which in Asia is considered good luck—"a symbol of purity and perseverance in adversity, greatly honored in Asia"— for one dollar each. Holding our lucky bamboo in the pedicure chairs, brainstorming ideas for this very book, all we could think of was…bamboo. And maybe, because we were having our feet rubbed at the time, luxury and pampering—chaise lounges, terry robes, and turbans. This was Old Hollywood tropical glamour, back when the Hollywood dream machine knew they were in the business of making Stars. A rising starlet could count on her studio boss to set her up in swanky style with her own bamboo-filled bungalow at the Beverly Hills Hotel. "Lush, leafy bamboo wallpaper," said Cynthia. "Mmmm."

Reality

Sure beats the sound of "small studio apartment" anyway. Start appointing the bungalow with a single bamboo roller shade and cover the floor with a lacey rattan rug. There's a nice spot for a deep-seated bamboo love seat with leafy, bamboo-print cushions. Nearby, a glass table for two and pair of those straight-back gilded bamboo chairs used at catered weddings. A long, low bamboo credenza stores everything—sweaters to dishes. Bric-a-brac on top: a cigarette box (cast gift from *Smoke Gets In Your Eyes*) holding a deck of cards for solitaire. Nicotine doesn't help you get the young roles.

To separate the livin' from the lovin' space, raise the bed area onto a platform. At the foot of the platform, cut a hole to sink a planter, so a screen of practically real bamboo appears to be growing right out of the floor. Load the bed up with silk pillows made from vintage hostess pajamas and dressing gowns. Use a breakfast tray for a night table with a copy of *Variety* stashed in the pocket.

Don't forget this is a poolside suite with a wraparound view. Running from the wall behind the bed to the adjacent wall is a blown-up digital photo of the actual pool and bungalows at the Beverly Hills Hotel, like they have at that New York nightclub Bungalow 8. Hold on a second, buster, one thing's missing. Oh yeah, the star on the dressing room door.

Ask Swelloise

How to Fluff Up the Down: *One way to increase the loft of a down comforter is to tumble it with a pair of clean sneakers in the dryer (on low).*

Grandma's Guest Rooms

Cynthia: When I was little, my brothers and I loved to sleep over at my grandparents' house because they had theme rooms. Every bedroom had a different motif. The Cowboy Room had cowboy hats hanging on a hat rack, cowboy boots lined up at the foot of the bed, horse blankets, a saddle thrown on the arm of a chair. Then, of course, there was the Indian Room, full of headdresses, papooses on the wall, Navajo rugs for blankets, turquoise jewelry framed in shadow boxes.

The Victorian Room was all girly and lacey with lots of little flowery things, a giant four-poster bed, framed portraits of Victorian women, down to the doily on the dresser with framed miniatures of my grandmother's grandmother and her Victorian-era relatives. When I grew up and had my own guest rooms to decorate, I adopted my grandmother's tradition. I did a cowboy room, which I call the Rodeo Suite, and then indulged some of my own dream themes. The best was the Vegas Room with a velvet Elvis painting, lava lamps, and rhinestone bijoux on a mirror-tiled dresser, a bad tuxedo hanging on the door, and three chocolate cherries on the pillow at night.

Word from the Wise: *Madame Ritz*

"Always line lampshades with pale pink," said the hotelier—the light is meant to be flattering to the complexion.

Hotelier's tricks for maximizing space, minimizing noise and creating five-star luxury. Make the bedroom as accomodating as a boutique hotel room...

❖ Mini bar, of course

❖ Nice hangers in the closet

❖ Double draperies so, depending on the amount of shut-eye you need you can either just draw the sheers, or go for the full-on bat cave effect

❖ Leave a 12-inch aisle next to the bed, just enough room for a vacuum cleaner

❖ Closets that light up

❖ Blow-dryer and mirror

❖ Keep a small shelf outside the door, like they have at the hotel Uraku, in Tokyo, to rest your bag and get your room key out

❖ Bedside lamps with dimmers

❖ Fresh flowers—the Hotel Crillon changes their long stem roses every day

❖ Magic fingers

❖ Access to all your needs from the bed so you can dim the lights, watch

❖ TV, listen to music, reach the minibar (almost), make a phone call

❖ Make like the Mondrian Hotel—drag a bed outside for seating on the veranda

CHAPTER THREE

Design for a Livin' Room

THINKING OUT OF THE FOUR-WALL BOX

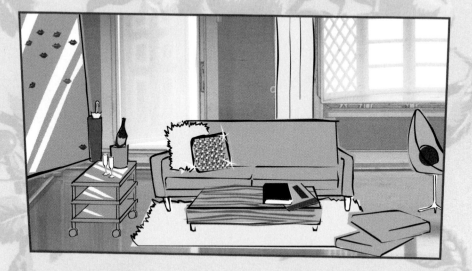

Get off the couch

Hey, wake up. You fell asleep on the sofa *again*.

Anyone who watches TV knows the sitcom model for the American living room is *booorring*. Sofas front and center in nondescript patterns and bland colors. Weak coffee tables. How to break the formula? Not easy when you spend so much of your prime time sitting in that setting watching that set.

Send the living room back to rewrite.

Living rooms should say more about the characters who live in them—and their antics. This is your big room, don't blow it on a cliché configuration. The sofa is not the center of your universe. Reconfigure the layout. Hotel lobbies and grand Fifth Avenue apartments are set up in "vignettes"—a backgammon table here, a love seat there—small, self-contained areas to read or lounge in and jump into the nearby action.

This is, after all, where you get the gang together, play games, show off your collections. So let your interests dictate the design. College guys know this instinctively, when they put a pool table in the middle of the living room and nothing else. It all boils down to: When you're not cooking, bathing, sleeping, or working, what do you like to do? WHAT DOES *livin'* MEAN TO YOU? A chic boîte for entertaining? A lair for seducing? A haven for your secret pastime? (Pretending you're the deejay who ran Dmitri from Paris out of town.) Transform the living room into your own hotel, club, screening room. It doesn't have to be permanent. The ambience can change with the seasons, even from day to night, as easy as you change channels...

TOP FIVE TV *Living Rooms*

On the classic sitcoms, the families entered your heart—and so did the furniture.

The Dick Van Dyke Show
148 Bonnie Meadow Road
New Rochelle, NY

From the grass-cloth wallpaper to the Swedish fireplace with a built-in love seat, Rob and Laura Petrie's Westchester ranch house was a diorama of contemporary sixties suburbia. Swell for entertaining, it was a big, open space with plenty of room for charades, card games, and flashbacks. Fun from the moment Rob tripped over the ottoman in the opening credits.

The Addams Family
Address Unknown

The Goth Petries. Their "altogether ookie" Victorian was a mausoleum of family life, rich with imagination and passion. Morticia's peacock chair, the bearskin rug, the dartboard with knives, Uncle Fester's bed o' nails. Sexy! And still enough space for Gomez to practice his fencing or seduce Morticia into a quick tango.

All in the Family
704 Houser Street
Queens, NY

Memorable if only for the king and queen easy thrones that sat front and center, with a table in between for Archie's beer. Way before Roseanne, the Bunker bunker boldly showed blue-collar décor: spare and humble but not generic. You still had the feeling that they cared about every item in the house. Especially when Arch would catch Mike sitting in his chair and yell, "Out!"

The Mary Tyler Moore Show
119 North Weatherly
Minneapolis, MN

In her second TV incarnation (after The Dick Van Dyke Show), Mary downsized, but her fab studio apartment epitomized seventies working-girl chic. She'd always fix that M on the wall when it was crooked. Okay, she had to sleep on a pull-out sofa. But she had a nice balcony, where she could have a romantic moment with a date staring at the snow falling on the Twin Cities.

The Brady Bunch
4222 Clinton Way
Los Angeles, CA

Sherwood Schwartz, visionary TV producer and creator of The Brady Bunch (and Gilligan's Island), broke the sitcom set mold with a renovation of the suburban tract house to fit his vision of a "broken home" as a modern blended step-family. When you picture the Brady's living room, you don't think of a lumpy sofa. You think of the stone walls, the open staircase, and the Chinese horse sculpture under it. Granted, Mike Brady was an architect, but you can draft some simpler plans and still be groundbreaking.

The Commitmentphobe's Paradise

Cynthia: *When I found my apartment in New York, I called it the Maxi-Pad. It was a big empty loft. I loved the openness—like a blank canvas. It seemed so peaceful, so soothing. But it wasn't exactly practical. I needed some walls. When I built them, I wanted to preserve the anything-could-happen feeling, so I left it all white. A twelve-foot-long white couch. White wall-to-wall carpeting. To separate the kitchen, I put up white sheer scrims. With light on one side, you can see through them for sexy silhouettes. If the light is on the other side, you can project on them—a use for all those travel slides.*

Even I had to admit it needed a splash of color. I considered painting, but couldn't decide what color. I couldn't commit! The answer hit me when I was at a gallery show for Dan Flavin, an artist from the forties who does sculptures with fluorescent lights. I got some fluorescents of my own with colored gel sleeves—yellow and orange, green, pink, purple—and put one on each wall. That way you can flip on the color or flip it off.

But white wall-to-wall? Wasn't the point of this to be practical? To minimize dirt damage, I put a basket of paper shoe covers from an industrial supply catalogue at the door for guests. There've been a few accidents, but you can't cry over spilt orange cocktail from a two-year-old's birthday party. Nothing a few three-foot-diameter colored carpet dots can't cover up.

Now Change Everything!

A snowblinding Maxi-Pad may seem extreme, but it beats the "when it's done, it's done" attitude to décor. Then you risk ending up with Aunt Sheila's condo, with the same gilded wallpaper and powder blue rugs for fifty years. Not that there's anything wrong with that! But a swell house adapts to the seasons, dresses up for evening, and swings with your moods.

Summerize and Winterize

When you're retiring warm woollies to storage and pulling out the polka-dot bikinis, the house should get a fresh look, too. Something more stimulating than switching the silk hydrangeas to faux autumn-leaf floral arrangements, and the candles from Christmas red to beige. You don't have to do a whole overhaul every season. Not even every room. Just one change can, as the Japanese say, "Refresh the eye."

When the thermometer rises... Turn the sofa toward the garden. Or if you lack greenery, swap the Mongolian fur throw cushions for Victorian reflecting balls from the gardening store. Hang a view. Your best sunset photo, blown up, cropped, and framed into a triptych. Buy new colored towels and have a tailor stitch them into a beach-blanket afghan. Designate a "mood wall" and stripe it in Lifesaver tropical fruit colors. When the stripes come out crooked, paint more in the opposite direction and call it "Madras." Lean a surfboard in the corner. Accessorize with summery fabrics: cotton piquet, terry cloth, canvas, eyelet, seersucker, gingham, toile. Put up some *Beach Blanket Bingo* movie posters, surf videos by the VCR.

When the mercury drops, ready the joint for hibernation... Now turn the sofa to the fireplace. Or, failing live flames, toward the TV playing your yule-log video. Rake leaves *in*to the foyer. Unfurl the furry area rug. Upholster the mood wall with cozy ultrasuede tacked in place with little nail heads. Put the

chess set between Persian lamb stools. Use winter fabrics: quilted, brocade, embroidered, velveteen, suede, leather, Woolrich, knits, cashmere, corduroy, fur. Lean a toboggan in the corner. Ready for a midnight run!

NIGHT AND DAY—THE SIXTY-MINUTE MAKEOVER

When company's coming, put a little lipstick and powder on...the apartment.

Rrring. Johnny's on the blower. He's at the airport on a layover. Can he come by? Can he ever! Girl, you gotta turn this cozy shack into Whoopee World—*and fast.*

Get those browning bananas off the Formica. Stash the TV and turn the trolley into a gleaming roll-out bar. Remove cushions from the back of the sofa and before you know it, you'll be *reclining.* "Recover" corduroy pillows with beaded sleeveless shell tops buttoned over them. Turn the thermostat up. Then you can say, "Is it you, or is it getting hot in here?" Backlighting is essential: Pull the sofa out a foot and put a pair of can lights on the floor with a foot-pedal dimmer switch. So you can turn the lights down, or—if you go off the boil—back up.

Whip out the special occasion shag, the white flokati pillow you don't

Furniture EMS

No-Despair Repairs: *Wine spills. Cigarettes burn. Relatives leave you with hand-me-downs. Use protection! Put felt pads on the feet of sofas, chairs and the backs of pictures so they don't scratch the floor or wall when you shove them around the room. ScotchGuard everything. But when furniture prophylactics fail and accidents happen, remember they can be the antecedents of joyous inventions. Say Uncle Al extinguished a stogie on your Italian leathah sectional and you're burning up. Instead of calling the upholsterers or your lawyer, patch things up: big red squares stitched on the creamy buttah. Stitch suede on the worn "elbows" of a corduroy armchair. Embellish a torn plaid chair with gold paillettes, buttons, or kilt-size safety pins.*

42

use everyday because it gets dirty and sheds on everything. Show him you're not all fluff with some intellectual propping. Stroke your chin and choose a few well-placed cultural conversation pieces. Charles Highway, the aspiring lothario of Martin Amis's novel *The Rachel Papers* put out literary accents, a collection of William Blake's poetry and a copy of *Time Out*—"an intriguing dichotomy" on the coffee table. *Tick tock:* time to get out of those sweatpants. Perhaps leave a lacy nothing taunting from the dresser drawer? Too obvious. Put the La Perla shopping bag on the kitchen counter instead, nonchalantly holding your recyclables.

Oops! Spillage on the sofa. Jitters much? Pin one of those silk flower pins you'd written off as dead over the stain. Oh, jeez: almost forgot. Reprogram the doorbell. Just in time. The *I Dream of Jeannie* theme tinkles into the room. Yes, Master, he's here!

Word from the Wise: *Audrey Hepburn*

Monochrome-mania: *Hot colors advance, cool shades retreat, and all that important jazz. But the legends color outside the lines. Diana Vreeland had a penchant for red lacquered walls, to match her lipstick. Andy Warhol aluminumed the interior of the Factory, painting every square inch of the fabled party hangout metallic. Audrey Hepburn's taste in decorating, like her taste in clothing, was low-fat. Everything was white. La Paisible, the country retreat she called home in Switzerland, was the kind of place that might have called for Fowler chintz and a Chippendale highboy. Instead she had white walls, floors, couches, white wicker* 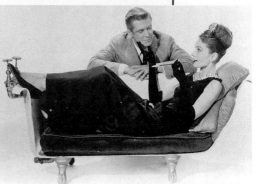 *furniture, white down to the Limoges ashtrays and the Rolls-Royce out front. She broke it up with bold color accents in blue, green, and orange, family pictures in silver frames. And the occasional bag of Doritos. Just kidding!*

Scheme 1 | *Sweloise On Her Own*

Dream

Every girl fantasizes about horses and hotels—preferably not at the same time. Perhaps you've outgrown the need to live on Chincoteague, but every now and again, you still long for that room-serviced idyll where you arrive home, après-shopping, to thrust your hatboxes at the bellboy and repair to the lobby to read international magazines, while secretly on the lookout for Mr. T. D. Handsome to check in.

Reality

I am Sweloise. I am twenty-six. I once lived at the Ritz-Carlton.

True, my circumstances have changed a bit. After a dysfunctional childhood running heathen in a four-star hotel, and a fleeting marriage to a *rawther* felonious fellow who claimed to be a Hilton, I've taken rooms in a prewar doorman building on East 81st Street. And now, I'm making a go of it as a decorator!

Naturally, my background in décor is primarily nineteenth-century, mid-Manhattan "chateau"—marble lobbies, solid mahogany doors, Swiss organdy curtains. But styles have changed, as have I. And I'm glad! I *am* pretty and I am a person. So, I asked myself: "Sweloise, how can you salvage the elegance of your childhood without being all stuffy and prissy and *boring?*" How to re-create the glitter of 1,650 crystal chandeliers, but not like a place where you'll get sklonked on the head for putting your feet up on the Italian brocade sofa? Oops. Did I say too much? My alimony agreement did come with a confidentiality clause.

In any event, the question was: How to marry (perish the word) the old with the new? Turn uptown upside down? A style conundrum for the ages. Light me, *cherie?* Let me show you around.

Word from the Wise: *Sister Parish*

The high priestess of high-WASP decorating spruced up the blue-blooded domiciles of Babe Paley, Brooke Astor, and Mrs. John Kennedy, deformalizing patrician homes with her genius for the cling-clang of patterns and clashing colors. She liked to undecorate. "My Undecorated Look has meant rooms that are comfortable and friendly, imaginative and warm, expressing a certain continuity," she said. Sis, who was unschooled and could not even work a tape measure, claimed to go on instinct. No guidelines. A few lessons, however, can be deduced.

Trust your eye—and let it wander. When, as a twenty-one-year-old bride, Sister inherited a suite of ebony furniture covered in Aubusson, she horrified the in-laws by painting it white. She would put four patterned chintzes in one room, and intrepidly tie it all together with a striped rug made from carpet samples. Connect your own dots of pattern and color: the blue-and-white toile goes with that blue-and-white oversize gingham that goes with pink-and-white oversize gingham that picks up the pink floral chintz of the bay window seat. Paint the floor a courageous color like crushed raspberry, imperial yellow, or apple green.

Throw in personal quirks. A deer head painted ivory to blend in with the painted wood walls. Sis introduced American crafts to fancy homes. A worn cotton quilt against the finest linens. A striped rag rug with a walnut and chintz fauteuil. But before you can mess things up, clean up. At the start of a job, Sister would "tray" a room, purging it of its geegaws (bad wedding gifts, etc.) by wheeling around a tea cart and piling on offenders. Clients would come home and scream, "I've been trayed!"

Tuscan Inn

Ilene: *Looking for my first apartment in New York, I knew exactly what I wanted: a lofty downtown space with sun, high ceilings, exposed brick, and lots of prewar character. I ended up with a cookie-cutter one-bedroom in an uptown high-rise, a fleet of doormen, and a fountain in the driveway.*

The building's only distinguishing characteristic was that it was in the movie Mickey Blue Eyes, *standing in as the backdrop of a catering hall. But my dad had made me an offer I couldn't refuse. Subsidized rent. I'd just have to supply the character and charm to these soulless modern digs.*

I aged the walls rose, scoured every flea market on the Eastern seaboard for a rusted wrought-iron candle chandelier, and hung it from a chenille tasseled cord over a long farm table. I put up a baker's shelf with antique colored bottles. I had oversize baskets, Bordeaux damask drapes, an emerald damask bed, a piano with a needlepoint seat cover, a gilded magazine holder, garden gargoyles on the terrace. It was lovely—like living in a well-appointed Tuscan villa in Las Vegas.

I lived "up at the villa" for a few years before I started dating my boyfriend, Rick, who teased me about my "feminine" apartment. I, in turn, mocked his obsession with sixties-modern furniture—all the kooky formica stuff I'd grown up with. Then it occurred to me that I lived in a sixties-modern building. It wasn't the building that was uncool, it was me!

I decided to embrace the Formica, Danish wood, and primary colors I'd loved as a kid and began to reappreciate them as an adult. I donated all Tuscan collectibles to younger relatives in need and started over. The puffy Ralph Lauren armchair was replaced with an orange Danish rocker. I swapped the Victorian dresser for a white laminate one with lime green plastic drawers and painted my bedroom ceiling kiwi. A big George Nelson bookshelf-desk unit. "Clean and lean" was my new theme.

Sadly, my conversion came too late. Dad's "investment" was ready to be cashed out—and I was de-nested. Bad timing for my design ambitions. Not so bad for my love life, since Rick asked me to move in. What's more, we were now design compatible. Men. Hmmm. Was this their plan all along?

Scheme 2 | After-Hours Hideaway

Dream

In the early days of Saturday Night Live, John Belushi and Dan Akroyd had a private club in lower Manhattan where the not-yet-ready-for-prime-time players and musicians and girlfriends and groupies and managers and hippest of the hip could collect after the show and bring the sun up. It wasn't fancy: Pabst Blue Ribbon, instruments lying around for the Rolling Stones or Patti Smith to jam with, if they'd been on that night. Even these guys, with entrée to the most exclusive joints in NYC, had to create their own. Don't we all! Often the hippest place is the one you make yourself.

Reality

Make yourself diva-in-residence at the ultimate after-hours club. A place to unwind after work or bring the party home. All it takes is the right props. *Tap, tap. Is this thing on?*

Start the rec room with the bandstand, a wooden platform in the corner. This is where you keep a Ludwig (pronounced Lewd-vig) drum set, to go live with your aggressions. It's not only a classic instrument (Ginger Baker, the drummer from Cream, and Clive Bunker from Jethro Tull had them), it's also a beautiful piece of furniture that comes in custom car colors like candy apple red or tangerine. Start collecting instruments for the backup girls and boys: tambourines, maracas. That way, if anyone feels the urge, you're ready to jam.

For those who prefer to cool out and listen to inspiring influences, a pair of analyst's couches with headrests in chocolate brown wool, with the stereo between them and twin headsets. Go authentic studio-retro with olive green, three-pound

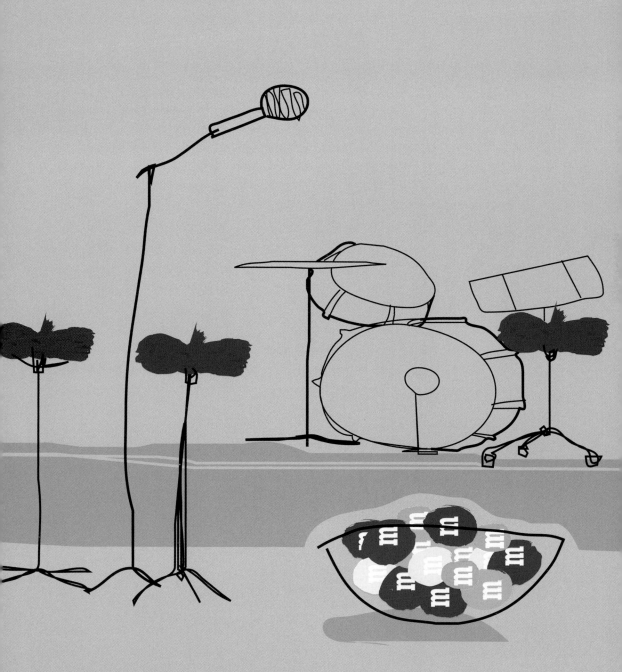

Kloss padded tubsters. Platinum lamé throw pillows remind you of that duet you did with Luther Vandross. Ooh, that was a sweet groove.

Thirsty? Designate a bar corner. It can be as small as half a barrel, just something to stand behind. Glass shelves stocked with a few ace brands. And, "No Coke, Pepsi." On either side is a shelf for resting cocktails, underneath are hooks for hanging bags or coats. Bar stools have red "beret seats"—woolen fabric with a tassel in the center—an ode to that ol' bebop hepcat Dizzy Gillespie. Or just one stool—the unplugged diva seat. The mic goes on the bar.

The audience sits in the "lounge": two gunmetal gray leather slabs. Fine sandpaper them so they've got some soul. On a coffee table in between, a giant bowl of M&Ms. No blue ones. You don't eat blue M&Ms, it's in your contract. For the walls, hang cheap LPs spraypainted glossy gold and platinum over the black vinyl. Substitute the labels with your own titles.

Now: sound check. Chicks get a bum rap for their musical hardware. One pink boom box and we all look bad. You'll show 'em. If you pay someone to paint and lay carpet, why try to put a sound system in on your own? Buy from a high-end audio store (they don't only have high-end prices) and their in-house pro will hook it up. You can get a knockout stereo for half the price of a pair of Jimmy Choo boots. It'll last a decade and blow away your boyfriend. So as not to blow away your fruity neighbors, put up acoustic tiles covered in reversed denim. Then no one'll even know when you scream at the top of your lungs, "Live from New Paltz, it's Saturday *Night!*"

Ask Swelloise

Whitening Piano Keys: When not in use, close the top. Sunlight yellows the ivories. Whiten yellowed keys by rubbing them with a soft cloth and a tiny amount of toothpaste (not gel; the old-fashioned brands, like Crest).

Where Do You Want It, Lady?

Calculating how much furniture to get, how big to get it, and where to put it seem like mystifying problems. Not if you know your math. Some handy equations:

For one normal-size adult, leave a thirty-inch traffic lane for passing between pieces of furniture. Around a coffee table, allow fifteen inches between chair or other seat and the coffee table for maximum leg crossing and minimal shin bruising.

Offcenter is better. Too much symmetry is the sign of a design novice. Different end tables or lamps often make a better fraternal twin set. Or a ménage à trois, if that's your bag, baby.

Up against the wall? A room needs to breathe. Move the couch out twelve inches. Put a table on the other side with a vase or something tall on top to give the appearance of roominess behind it.

Serenity now! Master the Zen vibe by keeping the furniture low and pushed against walls to create a feeling of openness. Long, horizontal lines convey a wide horizon. Break things up with a strip of vertical window, or wallpaper, your nod to the Chinese scroll painting.

Scheme 3 | *A Down Home Theater*

Dream

You know it's supposed to be sophisticated to adore evenings spilling over with red wine and Tosca. But when the whistle blows, your idea of heaven is to burrow in for an evening of channel surfin', TV dinners, and a coupla cold ones.

Reality

Out your secret love! Don't blow a lot of money on a credenza to hide the TV. Spend it on an even bigger telly. Worshiping the not-so-small screen doesn't have to mean damnation to a dump for overstuffed couch potatoes. This is your TV temple. Honor it with prime-time nostalgia and Technicolor touches. Decoupage the wall behind the tube with *TV Guide* covers. Scrap the sofa for a pair of La-Z-Boy recliners, then give them a sex change by re-covering them in orange velveteen or some fabric that's modern and feminine. *Poof,* it's a La-Z-Girl. Now for ultimate indulgences, flank the thrones with TV trays and a red cube fridge for holding a few chill bombs. Put a piece of Plexiglas over the coffee table: your take-out menus go under it for EZ ordering. Underfoot, a confederation of rectangular carpet pieces in primary colors: a test-pattern rug!

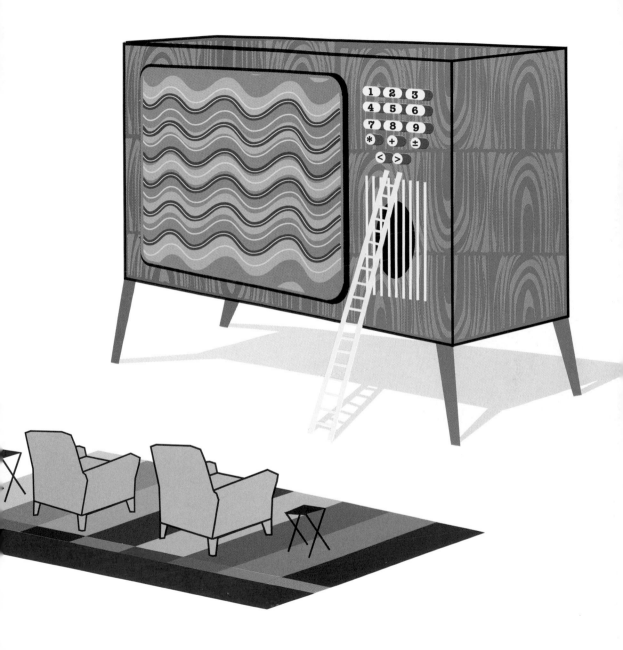

4 New Uses For...*Your Coffee Table*

❖ *Add a Plexiglas top and it's a frame. The photo gallery changes every time there are new guests to flatter.* ❖ *Tie on a padded slipcover and it's an extra seat.* ❖ *If it's mosaic mount it over the fireplace and call it art.* ❖ *Move it to the foot of the bed, like at a hotel suite, to store valises.*

Word from the Wise: *Richard Neutra*

A founding West Coast modernist, who was building sixties houses in the twenties, Neutra was a master of space and light. One of his tricks was ending bookcases short of their maximum height and filling the space with mirrors to create the illusion of an uninterrupted floating canopy.

Theme parks are scary: Used well, themes can provide an anchor. Your theme can be a design motif like curved walls or splashes of primary color, or something sentimental, like...sunsets?

Sunprize!

Ilene: Suns are the romantic theme of my beach house. My boyfriend, Rick, and I had our first big date at a hotel called Sunset Beach and two years later ended up buying a house together on Sunset Road. Every time we find something with a sun on it, it feels serendipitous. We try to steer clear of happy-face smiley suns or anything too gratuitously goofy, and go for things that have a use: a water pitcher from a tag sale, a shag rug, a set of Plexiglas folding chairs. The more abstract the sun design, the better. So when we stumble on a painting with random green-and-blue squiggly lines and notice that the title is Blue Ridge Sunrise, we exchange looks and don't have to say: Gotta get it.

Scheme 4 | *Womb Room*

Dream

Late one night, Cynthia and Ilene were cramming to finish the very book you're holding. We'd been working for hours and were starting to drift into a dreamlike stupor. Cynthia's head was snapping forward dangerously in midsentence. Ilene, paralyzed from the neck up, continued typing away, embalmed in Ben Gay. We needed to get out of Ilene's apartment. To get the chi flowing again, we decided to continue "working" offsite, climbed into Cynthia's '65 Galaxy convertible, and careened down to the Lower East Side, as if pulled by some primordial force. We sleepwalked into a neat, glass-fronted bar with a warm, enveloping ambience. It was called Suba, Spanish for "beneath," though the owner was French and, in another twist, friendly. We followed him downstairs to his subterranean grotto and blinked. Wow. A dining room that appeared to float. A floor surrounded by twinkling blue water whose submerged lights flickered moodily up the brick walls. Now we knew what had drawn us down here. In our ragged-out state, we needed nurturing, comfort—or a cute French guy giving us blood orange margaritas. A womb of our own.

Reality You know how people sit and watch a fireplace for hours? The only thing more mesmerizing would be staring at trickling water. While the whole moat might seem a little much (and sink your castle), you can simulate the soothing, aquatic effects on a smaller scale.

Step this way to your underground "island." You'll need to cross a small bridge by the doorway, made of subway grille. The island itself is poured concrete painted slate gray and lacquered to a super-high sheen until it looks like black glass or a wet stone jutting out of the riverbed. For the actual H_2O, splurge on an indoor waterfall. Not the kind with bonsai and boulders, but a clean cascade of running water on a sheet of mirrored metal, used sometimes in spas and storefronts. They can be purchased in all sizes from indoor waterfall retailers like Watersells.com. Some even come with display shelves in front.

Craft Single
Pocket Caddy: To stow the half-read newspaper or magazine, use slipcover fabric to make a cloth envelope with a long tongue that you can secure under the seat cushion with Velcro strips.

Now to make the vibe snug and warm, an Aubusson rug. What's a fancy tapestry carpet from Provincial France got to do with anything? In her book *Allure*, Diana Vreeland proclaimed people should drag their Aubusson rugs to the waterfalls and have a picnic on them. Who are *we* to argue? Squares of Chinese silver tea paper on the wall will add some feng *shwing*, and softly reflect the lighting. For seating—obviously—a cinnamon Saarinen womb chair and an egg chair. Then some square, boxy, shantung floor cushions in shimmery eye-shadow colors—gold and tangerine and olive tossed in with some water pillows—to pile up or lie on like floats in the middle of your ce-ment pond, as the Clampetts called their *Beverly Hillbillies* swimming pool.

CHAPTER FOUR

Waterworlds

A SWELL BATHROOM IS GOOD CLEAN FUN

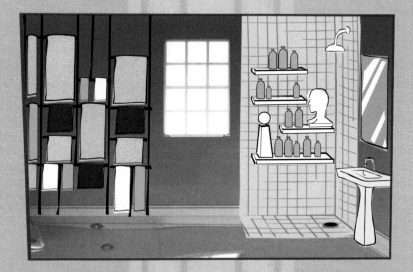

SANITARY INSANITY

Americans are, thank God, obsessed with cleanliness. Mr. Clean and the Tidy Bowl Man are folk heroes as powerful as Johnny Appleseed. But we can't let them out*shine* all other décor concerns. If the most exciting thing going on in your bathroom is the blue suds in the commode, guests are *forced* to snoop through the medicine cabinet. **LET'S DESTERILIZE THE LOO!** Even institutional bathrooms aren't institutional anymore. Warm up the porcelain without resorting to leopard wallpaper and crocheted TP cozies. There are other ways to soften the edges besides inflatable toilet seats. Go for clean and, uh, splashy.

We're old enough to remember when people thought twice about vacationing in Paris because the dreaded W.C. meant a pair of footprints and a hole in the ground. Phillipe Starck got France back on the hygienic fast track with his men's

room waterfall at the Café Coste, which he then brought to New York's Royalton Hotel. Before long everyone was doing "concept bathrooms." Bar 89 in New York's SoHo put in glass doors that shifted from transparent to opaque—as long as the user remembers to turn the lock. At Fun, a club in New York's Chinatown, you get a view of the opposite sex's sink on a video monitor.

The Romans knew the bathroom doesn't have to be strictly business. Their public baths were the multiplexes of ancient times, built to accommodate thousands with room for ball games, shops, even libraries and museums. The same swell spirit can apply on a less imperial scale. Adapt your space to your personal hygienic style—whether it's a spa-inspired "serenity suite" or gleaming "office tower black," featuring marble and smoked glass for your beauty empowerment rituals. It doesn't have to mean flushing your life savings on a cast resin wall sconce sink imported from Italy. The ideas here don't even require major renovation. Um, except maybe this next one.

Powder Room Reading: In the fourteenth century, common folk in England bathed

Scheme 1 | *Big Bath and Beyond*

Dream

Bend over to pick up the soap and bang your head on the toilet. The bathroom is so small you have to bathe in the fetal position. Who created these industry standards, medieval dwarves? Bathrooms used to be a place to stretch out, spend a relaxing afternoon nibbling bonbons and being rubbed with lotions by your faithful maid. Or so it seemed in those movies Hollywood used to make about the spoiled rich. In The Women, Joan Crawford idled away hours in a massive round tub that came equipped with a princess phone and a Viennese curtain she could pull down for privacy to make secret phone calls to her lover. You'd give *anything* to lounge away the day in a giant bed of bubbles in an indecently decadent bathroom.

Reality

"Anything?" the design devil on your shoulder prods with her little pitchfork. Would you give up that extra closet? Make the bathroom and bedroom equal sizes? Why not? Spend more time naked!

Knock down the wall. Tile three of the four walls in the new supersized room with four-inch powder blue tiles and powder-blue grout—white used to be the only grout going, but these days they can be tinted with mildew-resistant colored powders from coral to cerulean that won't turn all gray and dingy. For the fourth wall, take inspiration from the Mercer Hotel in New York, whose bathrooms and bedrooms are

in public "hot-houses," known also as stews, most of which were also brothels.

separated by a glass wall. Hang a rod with a floor-length curtain that can be pulled across for privacy.

Now you've got room for the Tinseltown tub of your dreams. Make it a sunken one. Sunken tubs are synonomous with the sybaritic excesses of fallen civilizations. Say that seven times fast. Of course, a tub filled with water and two people (isn't that the point?) can weigh up to half a ton. No wonder they fell! That could create some heavy problems in a high-rise. But don't give up. The Romans invented aqueducts to solve their irrigation problems. If you can't renovate, innovate. "Sink" your whirlpool tub by building a stepped platform around it. Climb up to step down—it's the same sensation without having to cut a hole in the floor. In the other corner of the room, mount a big-mama sunflower showerhead and put the drain right in the floor. To cover all this wide-open acreage, roll your toiletries from sink to shower on a chrome bar cart loaded with bath products—bergamot bath oil and such—in crystal decanters. Now bring on the bonbons!

Bathroom EMS

The cruddy shower floor really needs to be retiled, but the idea of getting into all that grout makes you groan. Make it an outdoor-indoor shower by pouring in a few inches of smooth pebbles. They sell them for planters at garden supply stores, ones big enough that they don't fall down the drain. No need to loofah your feet anymore.

Mark Your Territory

Ilene: *I grew up on Long Island in a house previously owned by Perry Como, the cardigan-ed crooner who was always hosting Christmas TV shows in the seventies. In the basement bathroom, Perry offered a glimpse of the flip side of his wholesome image. There he had a mural painted that, no matter how much it cracked and peeled, we would never consider painting. The aqua walls feature a line of chorus girls, each holding one of his hit singles, and Perry tickling the ivories with a cartoon balloon above his head that reads: "Ladies, please remain seated throughout the entire performance." A couple of years ago I finally got the joke.*

was portable and stood at his bedside, with room for two. It wasn't until the

Scheme 2 | *How to Suceed in the Bathroom Without Really Trying*

Dream

Congratulations, you're being promoted out of the typing pool and into the executive washroom. And it's everything you hoped: gleaming with good taste and amenities. State-of-the-art, high-tech ablutionary devices that you, being an observant VP on the rise, have already noticed are geared toward doing your business fast, with as little physical contact as humanly possible.

Reality

Good-bye subway tile, hello tycoon terrazzo. Reoutfit this outfit with anything dark and impressive. Black terrazzo looks like marble but is in fact chips of marble set in cement and polished to a smooth plane. It's less expensive but still good enough for the lobbies of six-hundred-dollar-an-hour law firms. Speaking of which, ask for a nonslip aggregate to keep the place from getting too slick. After blowing all this capital, you won't be able to afford Jacoby & Myers if someone has an accident.

What about fittings and fixtures? Follow this ancient management maxim: Have a hand in everything, leave fingerprints on nothing. Order an automatic sink, a kick-pedal toilet, and a hot-air hand dryer in lieu of towels, from a commercial plumbing supply company. To paraphrase Michael Douglas in *Wall Street:* Linen is for wimps. Hey, that shoe-polishing machine is a nice touch, but the smoked-mirror shower door may intimidate your guests. *Tough patooties!* Okay, okay, hang a pinstripe robe on the back of the door to show your softer side. Just so no one says you're not a team player.

1850s that bathrooms were installed in Buckingham Palace and the

4 New Uses For...*Your Bathroom*

ENOUGH RELAXATION. MORE RECREATION! ❖ *ENTERTAINMENT CENTER: Remember when you were a kid and could spend hours in the tub singing "Rubber ducky, you're the one...."? Get a karaoke machine in there.* ❖ *LIBRARY: If there's nothing you like better than reading in a bed of Mr. Bubble, buy a brightly colored wall-mount magazine display from an office supply company. Or build floor-to-ceiling bookshelves like Hemingway had in his hacienda in Cuba. Be sure to have a collection of Tennyson—the poet took half-a-dozen baths a day.* ❖ *SCULPTURE GARDEN: People worry humidity and proximity to toilets will ruin their art, but that's a lame excuse for placing a few shell soaps on the sink and calling it a day. Put up a shelf of stone sculptures, lay a bust on its side, and use the ear for a soap dish. You can put all kinds of things in there: at Barneys, the dressing rooms feature an installation of Tic Tacs, one thousand Q-tips dyed pink and glued on the wall in star formations, ornate Kleenex box covers arranged in a grid.* ❖ *DO YOUR BEST THINKING IN THE SHOWER? Meditate on something more stimulating than a candle: Get a message pad in there, the waterproof kind they use in scuba shops.*

White House. Queen Victoria saw to that with enamel-painted porcelain commodes.

Surfacing Ruts

As popular as the polio vaccine, porcelain is made of durable, non-porous materials that aid the battle against mold and mildew, inhibit the absorption of bacteria, never feel damp or icky, and can be doused in ammonia fifty times a day without breaking down. But germphobia shouldn't dictate design. Consider these sani-friendly materials an alternative to your basic ceramic bathroom tiles.

Chatahoochie stone

Like a carpet of pebbles and marble chips held together with epoxy, popular for outdoor decking in Florida retirement communities and considerably stronger than concrete. It can also be used indoors, and only costs about five to seven dollars a square foot. Wet Chatahoochie isn't slippery when walked on in bare feet, or accidentally run over by an out-of-control golf cart.

Uncorked

Popular in teenagers' bedrooms and playrooms of the seventies, cork tiles aren't the most obvious choice for the bathroom. But they're warm to the touch, cut down on condensation, and provide insulation. Plus, they offer a vintage feel, with full-bodied Bordeaux towels or a crisp white.

Flintstoned

Limestone and marble are geological cousins, they're both made from three-hundred-million-year-old seashells and prehistoric creatures. Limestone is more rustic, has a large grain structure, a matte finish, and sometimes you can see fossils in it. Neat! Marble, which comes from places where there was more heat and pressure in the earth, is a crystallized version of limestone. Footprints, water, and age give both more character. But staining doesn't, so they have to be sealed after they're installed and resealed once a year, or whenever water stops beading on the surface.

Wood

The trick is to prevent waterlogging. Pores are the problem: they let water in and dry rot. There are exceptions—cedar can get wet. That's why it's used for underwater stools in Japanese baths. Protect whatever wood you would with a few coats of polyurethane varnish. As with marble, when water stops beading, it's time to reseal.

Rub-a-dub rubber

Borrow easy-to-clean synthetic materials from other rooms. Take the linoleum out of the kitchen, or Pirelli off the racetrack. The Italian manufacturers of Ferrari tires and high-priced pinup calendars also make flooring: rubber tiles with little raised circles for grip are typically used in elevators—in elevator gray. But they also come in bright colors like yellow or red. So do Tek Tough mats, those perforated rubber mats used on the floors of bars that can be ordered to size at restaurant supply companies.

Carpeting

GROSS!

Scheme 3 | *Girl's Garage*

Dream

A bathroom that has nothing to do with serenity soaks and meditative moments. It's a "chop body shop," where you're the chief beauty mechanic. A technical genius, actually. A master of detail work, able to get frizz running smoothly, mask minor flaws, and defects with tiny undetectable brush strokes. You deserve a workspace where your power tools and products are as organized as a good garage.

Reality

One word: *Peg-Board.* Screw it to the walls, then either paint it primary yellow or red, or better yet, just leave it natural brown and paint on outlines of your tools and other hardware—blow-dryer, curling iron, blush brushes—in white, then clip in pegs and hooks to hang the respective tools. More Peg-Board to hang towels, with silhouettes designating bath, hand, and washcloth sizes.

Rest a shelf on a couple of the Peg-Board hooks. On the shelf's underside, glue the metal lids from your martini olive jars—then you can screw up the glass jars to hold Q-tips, cotton balls and other soft cousins of nails and nuts. Wheel in a Black & Decker red metal tool trolley for your cosmetic paint and spackle. That's what they use to hold the makeup at Jeffrey, a chic clothing store in downtown New York. Screw a screw-eye into the ceiling by the sink, another by the mirror, and you can move your mechanic's light, which comes with a hook, from one spot to another—and it will look cool with its safety orange cord. For a shower curtain use a dropcloth.

Ladies, start your engines.

Cecil B. DeMille was the discoverer of the on-screen bathroom.

STORAGE: THE BEAUTY PRODUCTS THAT ATE THE BATHROOM

They say the secret to a good marriage is separate checking accounts and separate bathrooms. Well, it doesn't help the cause of personal space to have every possible surface consumed by hair volumizers, foaming cleansers, and exfoliants. Product queens—and you know who you are—tend to monopolize sink corners, toilet tanks and bathtub rims as shelf space. Reign it in.

Beauty products, unlike clothes, do not become "vintage." Anything that makes the cut should be contained to safe and attractive storage facilities: an art supply cabinet with two big makeup drawers marked DAY and NIGHT. Or a pair of vanity cases. Instead of the usual wicker baskets, try plastic bicycle baskets instead—cute, colorful ones with flowers on them that used to hold your junk when you were two-wheeling around town on a banana seat. If there's a product you love and always use, display it like functional sculpture. Cotton balls, say. Instead of running out all the time for those little bags, buy them in bulk, then mount a whole bale on the wall in one giant clear bag.

> ### Invention
>
> **Ilene:** I'll come clean. In restaurants, I'm one of those germphobic paper-towel nuts who won't touch the bathroom door handle without one. So, you can imagine, I'm not into touching that toilet seat when Prince Charming has left it up. I've got a solution: the Automatic Seat Lowerer. Modeled on the same principles as an electric garage door, this commode can be raised or lowered with a remote control device. It operates off of an electric eye implanted in the bottom of the seat and can be activated by pressing a button by the light switch. The Crapper Clapper?

The epic-movie director always favored elaborate bathroom scenes, where he could

Anything Can Be Used for…*a Shower Curtain*

Travel beyond the world map and tropical fish. If you have a liner, the "curtain" can be made of virtually anything. It just has to be forty-five inches of fabric. The dry cleaner can stitch that together for you with some holes on top for hooks. Or you could just get a grommet kit from the sewing store and punch the holes yourself. And speaking of hooking, why not switch the squeaky-clean daytime curtain with a sexy, tarted-up version for evening. Come up with some ring alternatives for those plastic jobbies.

Plain canvas curtain with shoelaces through the holes.

Liberty print curtain twisted on with garden wire.

Venetian blind: custom ordered to the shower's size.

Circus banner with pom-pom trimmings.

An Hermès orange curtain tied on with logo ribbon.

Cutoff denim and strips of raffia.

Trench coat khaki and buckled belts.

73

ave women in various stages of deshabille and avoid censors who would have stopped

Scheme 5 | *The Empress's New Commode*

Nightmare

A wholly unremarkable bathroom whose only distinguishing feature is porcelain fixtures in baby pink. Flashback to the gaudy, grandmotherly bathrooms of your youth, with metallic wallpaper and furry throne cover. Vow to rip it all out and speed dial a contractor for an estimate. Whoa. Hang up and think, Maybe tacky isn't so bad. It could be Roco-kookie.

Reality

Retrieve from storage that crystal beaded, guilt-tipped chandelier Grandma gave you and make it the bathroom's spiritual anchor. The palace of Versailles had one hundred bathrooms—some of them must have had chandeliers. Switch it on. Ooh, so pretty, so sparkly, so Zsa Zsa! Take the porcelain pink to the brink by changing the fixtures to gold! Rather than make everything precious and cutesy, think grand scale, even if the scale is off. The bigger the better. Paper the walls with oversize prints, a lush pastoral landscape and a shower "drape" made from matching fabric, pulled to one side by a tieback looped into a brass holdback. *So élégante.* A stack of towels embroidered HIS and MINE, in gold, of course, *dahlink,* even if you're single. Too bad there isn't a bidet.* Use construction adhesive to fix an oval gilt frame over the rectangular medicine cabinet mirror. Put up a half-moon shelf, with a few *objets de beauté:* your Louis Vuitton vanity case spilling over with lingerie, perfume collection, and wig form with a sexy blond peruke on which you've clipped your hair baubles. But she is *amusante!* Though it used to be said that a French bath was a splash of perfume, they make the best soap. Put a collection of good French *savon* on a pretty dessert plate. Let them eat cakes of soap!

*** CRIB NOTE**

Bidet *In French, the word means "pony," because of how you sit on it astride. Originally used for douching and vain attempts at contraception, the bidet has long been popular in Europe but has always incited prurient reactions on this side of the Atlantic. After bidets were introduced in America around the turn of the last century, moral crusaders forced their removal. In 1950, the Hotel Molière in Paris called them "footbaths" to calm tourists.*

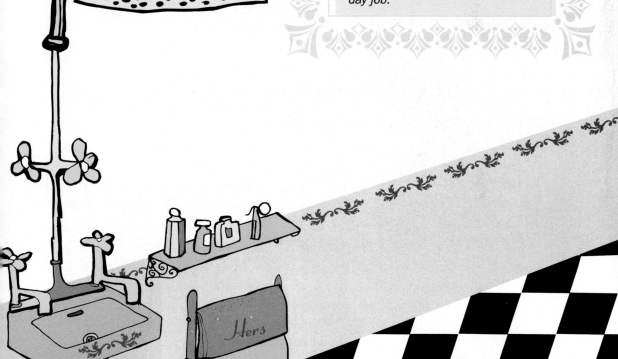

Harlequin furniture. In England, an ingenious, seemingly simple night table would

Scheme *6* | *The Mirror Has a Million Faces*

Dream

To walk into a mirrored box. A vanity kaleidoscope with infinite reflections—a narcissist's retreat with a bit of a trippy *Through the Looking Glass* feel. That's all, nothing deep.

Reality

Go for baroque. Crack the Yellow Pages and invite the glass and mirror guys to come on down and resurface *everything!* Smaller mirrored tiles for inside the shower area and ceiling, big panels for the walls, and sheets of mirror above the sink. Mirrors facing each other reflect infinitely, creating what the French call a *mise-en-abîme.* Like the Droste's Cocoa box with a girl on it holding a Droste's Cocoa box, holding a...

One shelf holds a collection of hand mirrors. Write a message on one: "You're so vain! You probably think this bathroom's about you." They say if water gets behind a mirrored surface, it can make the silver disintegrate. Don't worry about that—it could look antiquey and cool. The real problem is, where to put the lights? It's a textbook no-no to mount lights above the mirror—leaves bad shadows. Two strips of makeup mirror bulbs above the sink could do the trick. Romantic lighting is easier: just one candle will bounce off all the mirrors. When the mood is high and the lighting low, just make sure the floor's got some grip. One false slip could add up to about seven thousand years of bad luck.

open and unfold to reveal a wash stand, toilet accessories, a chamber pot, or

SHED A LITTLE LIGHT ON THE SUBJECT?

Arrgh. *Hate* that expression.

Grumpy in the morning, are we? Well, it certainly can't help to face the day beneath that unforgiving tribunal of fluorescent bulbs. Am I dreaming, or did I just land in an airport restroom after a red-eye from Sydney? Overhead lighting is the worst. The bathroom with its shiny surfaces needs warm, general light to soften the edges. Invest in some kinder, gentler lighting, like PINK BULBS. Or how about just calling your super and getting a darn dimmer switch installed?

Mirror in Mailbox

Cynthia: *Take it from someone who has colored lights all over the house, I never know exactly what I look like until I leave. My makeup may be too heavy—I could have the purple eye shadow on as lipstick. Who knows. And there's no mirror in the lobby of my building. So I glued one on the inside of the mailbox door and keep a lipstick in there. That way I can do a quick check on the way out if someone's picking me up or dropping me off. I stole that one from Holly Golightly (Breakfast at Tiffany's). She kept perfume in hers.*

a night stool and a bidet. Before toilet paper, Romans used "sponge sticks."

CHAPTER FIVE

Kitchen Aid

DON'T LET THE APPLIANCES DO THE TALKING

CHEF OF THE FUTURE

First, everyone was a foodie, able to identify an arugula leaf from mache at twenty paces. These days, everyone's a chef. Or thinks they are, judging from all the industrial home kitchens glistening with steel and granite workstations, walk-in refrigerators, and eight-burner ranges you have to light with a blowtorch to make a pot of tea.

Who needs $50,000 worth of scary brand names like Vulcan, Viking, and Wolf to follow a paella recipe or whip up a crowd-pleasing roast beast?

DO KITCHENS HAVE TO BE SO SERIOUS?

As our favorite *bubbe,* Ilene's Aunt Sheindel, might say: "Don't be such a big shot!"

When you learned to make French toast in home ec, you didn't have all that glamorous stuff, and everything tasted great.

We're not advocating a return to the icebox age. Remember Alice Kramden in *The Honeymooners*? All she ever wanted was a fridge she didn't have to defrost. And, hey, people blow a few grand on a plasma TV screen, why not on a Trawlsen glass-front refrigerator, if you think it looks super-chill? Splurge on the occasional DECADENT kitchen fixture when it suits your taste. But the most personal element of your kitchen shouldn't be a Miele Ultraquiet dishwasher.

Cater to your own eating and cooking style. Maybe your idea of a comfort food zone is one of those sunny yellow Formica kitchens on Nick at Nite, where everyone's always baking cookies and having a heart-to-heart. Or if you're an artiste, whip up a studio for your creations, a raw space with pastry brushes in tomato cans, where the blender can explode and you won't mind the mess. If you're always confusing food and sex—and who isn't?—make yours a spicy cucina where you could imagine shooting a remake of *Il Postino*.

There *are* other ways to heat up the cold, modern kitchen than such "country" touches as terracotta, chicken-shaped cookie jars, and avocados sprouting on the windowsill. Yuck. Close that old recipe book and start from scratch. As in cooking, you might find INSPIRATION from ingredients around the house, a food you love (tomato-print wallpaper!), software instead of hardware. Change with the seasons, or the latest food fashion. Say the only thing you make for dinner is reservations, and by your calculations the kitchen is just a euphemism for two hundred square feet of wasted real estate, then—bam!—turn the space into a coffee bar. Long as there's fresh bagels on the counter, who's complaining? As Bubbe Sheindel would say, "ENJOY!"

Scheme 1 | Kitchen Under Glass

Dream

Philip Johnson, the architect, built a house in New Canaan, Connecticut, where all the walls are glass. Everything's visible. Imagine, for the cook with an exhibitionistic streak, a totally see-through kitchen—the truly "naked chef." Just remember to keep the blinds down when you're beating the eggs or whipping the cream.

Reality

(Warning: This fantasy is only for the most uninhibited of chefs and the *very neat*.) Make every surface transparent. Start with clear countertops, so that you can see all the contents of the drawers underneath. (So *that's* where those grapefruit spoons went!) Plastic won't do because it scratches, but one-inch tempered glass with beveled edges should hold up nicely. Cabinet doors? Take 'em off, baby, take 'em all off. Well, except maybe the ones under the sink—trash bags and yellow gloves are surefire appetite crinklers. Leave the cabinets bare if you like, or replace them with plastic panels. Go to your friendly neighborhood restaurant supply company and bring home one of those fridges with the sliding-glass doors they have in delis. Make sure it's well—or at least attractively—stocked. Keep flowers in front of the milk. For the breakfast nook: a glass table set with glass dishes, surrounded by Lucite chairs. Overhead swings a glass globe lamp. On the wall, a fish tank filled with iridescent rocks makes a nice home for your pet lobster, Mr. Claw. *Ouch.*

Scheme 2 | *Snap, Crackle, POP*

Dream

Jeff Koons's hyper-realist painting of a grilled cheese sandwich with the fromage dripping succulently over the edges doesn't just make your stomach growl, it gets you thinking. Hmmm. Hmm, hmm good. Koons elevates the mundane—simple food, for instance—to iconic status by treating it as art. Why not extend the metaphor to the rest of the kitchen?

Reality

Cruise the supermarket aisles like a sweepstakes winner, filling a shopping cart with inspirational iconic brands: Bumble Bee, Skippy, Tropicana, Dole, Ritz crackers, Oreos...Wonder bread! That's the one. Those multicolored dots are classic—and sort of Damien Hirst, the dot-painting Brit artist. Replicate the graphic at home, painting the blue, red and yellow dots on the ceiling, the cabinets, wherever they look cool. Your own art project. Which *means*...dot, dot, dot...you get to go to the art supply store. Woohoo!

To make sure the circles come out good, make a stencil. Dig up a compass—remember those?—and draw a circle on a piece of cardboard, then cut it out with an X-acto knife. Make a separate stencil for each color. Before placing the stencil on the floor or wall, spritz Spraymount on the back so it's tacky and doesn't slide around or lift up when you're painting the dot, which you can do with basement paint or deck paint. The hardware store guys will probably pooh-pooh the idea. Rebel against them. You're an artist, right?

The Wonder bread dots will look particularly tasty on your "spilt milk floor." That is, a special polyurethane-and-paint mix that the painters actually pour onto the floor and which hardens into a super-smooth finish. Work the milk theme and cover a whole wall—top to bottom—in cereal boxes. Sugar Pops? Wheaties? Special K? Stack them up. Stick a morsel of Blue Tack (the sticky blue clay you picked up at the art supply store) on the contest side of the boxes to hold them up.

A wholesome tableau, but how about something to spoil your appetite? On the countertop, keep a row of standing cake-display plates with glass tops covering big sugary birthday cakes bursting with blue and pink roses, and other marzipan extravaganzas. In the bakery window, they look merely inedible, but at home they look positively artistic, a Wayne Thiebaud painting come to life. "Common objects become strangely uncommon when removed from their context and ordinary ways of being seen," said the sixties realist painter who did sweet still-lifes with titles like, *Candy Apple* and *Cupcake.* At a bakery supply company, they'll have those Styrofoam "fake-cake" dummies that get iced then displayed in the bakery window. You can decorate them yourself with royal icing and gum paste flowers, or have them decorated by the over-the-top Italian bakery that you ogle on your way to work in the morning and wonder, "Are those things real?" They're not. And they last for years.

Scheme 3 | *A Movable Feast*

Fridge - Delux

Dream

In a living room, when things are feeling static and boring, you give the sofa a shove and everything looks different. In the kitchen, however, nothing budges. Countertops, dishwasher, microwave—it's all predetermined, built-in, and locked in. (Deep sigh). Maybe you can't change your life but you can change your kitchen. Free your range.

Reality

What law says all the kitchen fixtures have to be so fixed? Photo studios are filled with equipment, too, but it moves. Everything can be wheeled out of the frame so any spot in the room can be used for shooting.

Recompose the kitchen. Renovate without buying all new appliances by just reorganizing what you've already got. Sink, refrigerator, stove, and appliances on one side of the room. Leave the other side blank. The food stylist needs spreading-out room, to think, to create, to *see*. Then in lieu of traditional cabinetry, do like they do at the photo studio for storage: carts on wheels. They come in all different sizes—long, narrow, rectangular. And, strangely enough, they often come from restaurant supply stores. Some could hold dishes and cutlery, others wire whisks and rolling pins. That way they can be wheeled to wherever you're working or serving, even outside. Clamp lights can be fixed to the sink or the table, wherever you need them. A butcher block table on wheels can double as a counter surface and be pushed away at chow time.

For the full studio effect, use plastic floor tiles that can curve where the floor meets the walls for easy clean up. Snap photos of the prize-winning dishes you've made and hang the prints with clothes pins "to dry" on a line over the double sink. Work it! Mount a roll of seamless back-drop paper that can be pulled down for different color backdrops, or, scenery. Rent the Materhorn for your fondue party and say, "cheese."

Where's the Beef?

Has the shine gone off the linoleum? Are you so busy bringing home the bacon that you never want to make any? One way to turn the pilot light back on could be to remind yourself of the bond that brought you and the kitchen together in the first place. "Food, glorious food!" (Sing it, Oliver!) "Hot sausage and mustard / When you're in the mood / Cold jelly and custard…" Cater the design to your specialty, and if you don't have a specialty—jeez—you gotta have one.

THE MAGIC PAN

Zut! Your kitchen is so small you could burn your buns on the stove while washing the dishes. No problem. You only know how to make one thing anyway: crêpes. At least you graduated to grown-up pancakes! Imagine your tiny galley kitchen is one of those tiny crepe stands in Paris. Leave a couple of griddles on the burners, ready to go, a big porcelain bowl for batter, and a whisk. The cupboards are just filled with jars of fruit confitures. Now put all that stuff away. The handyman is here to cut a pass-through into the living room, for customers to bark orders. A small chalkboard nailed up on their side features the crepe of the day: Nutella. While waiting they can admire the view of the Eiffel Tower behind the chef—don't let them get close enough to see it's just a painting.

HOME ON THE RANGE

Vegans, cover your ears. The rest of you, cover a wall with butcher paper, mount a pair of steer horns. The Weber Steak House in Deerfield, Illinois (right near Cynthia's hometown!) is *filled* with giant Weber grills, flaming up T-bones *indoors*. Too bad your smoke detector won't let you get away with that. But darn it if you're not ready to make the purchase of your life: a big-ass indoor grill. Install a row of cook surfaces, the kind made by Miele and other fancy appliance manu-

Almost Famous Deli

Ilene: I love Jewish delis and Italian restaurants that hang photos of all the celebs who've eaten there. I wanted to do the same thing in my kitchen. So I hang photos of my friends and relatives, the celebs of my life. Anybody with an eight-by-ten glossy is famous enough for me. So is anybody with a portraity snapshot that can be blown up to size. My dad had a glamour shot from his high school yearbook, where he looks "just like Robert Taylor." Who? I have one actual famous guy up there—Regis Philbin (it's a long story). The only rule is, everyone has to autograph his or her picture, of course, with an inscription. Sez our pal Tad on his pic: "Now That's *Strudel!*"

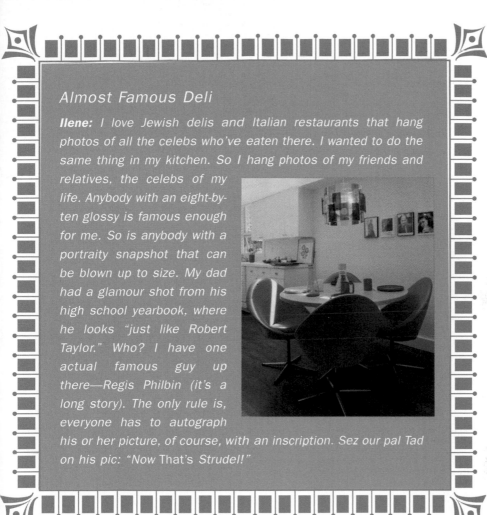

facturers, that set right into the countertop. Not one but two electric barbecues and…*your very own electric fryer* for steak frites. Omigod, omigod! Okay folks, Steak Gal is just doing the crazy contestant dance. And that's not all…the grill is the big prize, but the whole room is sizzling with rare finds and well-done touches. A kitchen table made from rough-hewn butcher block, always at the ready with white oval plates, courtesy of Peter Luger's steak house in Brooklyn. Chair pads made of the silver, heat-resistant fabric used for oven mitts (good for when conversation gets heated). And, what the heck, a Weber grill, retrofitted as an ice bucket for beer, wine, or 'tinis. To keep it buffed and shiny, a lifetime supply of Turtle Wax.

3 New Uses For...*A Kitchen*

Spa-go

Instead of putting fatty photos or empowering sayings on the refrigerator, make the whole room a study in low-cal motivation. Welcome to the Serenity Suite. Here you can hang out to kill time between treatments or appointments, sipping lemon water, nibbling fruit, and making vows that from now on you'll live on massages and green tea. Replace the table with a chaise lounge. Everything's in white terry cloth, the walls are awash in hydrotherapy blue. Sand down anything made of wood till it's nice and blond. Serenity now! Fill the rice cooker with hot hand towels. River stones look "healing" in the sink. A salon chair for applying mango hair masks, or barbering your boyfriend. Scent the place with lavendar, primrose, grapefruit, and other ethereal anti-appetite aromas. Is that your stomach growling?

Coffee Tea or Me?

Known fact: people who cook can't make good coffee, and vice versa. If you're more vice than versa, reconfigure the kitchen into your own personal Starbucks. Good-bye Mr. Coffee, buongiorno Italian espresso machine. If high school kids on minimum wage can make latte foam, you can. Keep the gleaming machine front and center. Whenever someone asks for a cup, try to sell them on the covered cake platter with bagels, brownies, and Rice Krispy treats. Fill flour-sugar-tea canisters with sugar packets, tea, and chai (whatever that is). A couple of coffee-bean-bag chairs. For extra flavor, ask the competition on the corner if you can have some of their empty bean sacks imprinted with their country of origin—Colombia, Ethiopia, Seattle (that's not a country!)—and burlap the walls by soaking the bags in a thin plaster of Paris and sticking them up there. Oh, and while you're at the coffee place, could you find out where they get their cups? Then sweet-talk the cup maker into a small order with your insignia on it: Bean There Done That? Maxine's House? A CD box with your own percolating hits: Squeeze's "Black Coffee in Bed"; Sinatra's "The Coffee Song" ("They've got an awful lot of coffee in Brazil").

Short-order décor

So what if you're a take-out queen, this is your castle! Proclaim the kitchen a place not for cooking but for ordering and eating. Make it your favorite neighborhood joint where you always get a nice booth for four, even if you're just one. (Another great item you can pick up at the restaurant supply company.) Do up the walls with quilted aluminum, the stuff on the sides of thermal food carts, because it's swell looking. Stop short of other fifties diner kitsch. Mount a thirteen-inch TV on a wall-bracket, white to match the booth, to keep an eye on the game while you scan the menu, which is as thick as a Greek diner's, a binder filled with your own take-out menus covering everything from eggplant parm to omelets.

Scheme *4* | *Kozy Kitchen*

Dream

In Colonial times, people hovered around the kitchen because it was often the only heated room in the house. And ever after, the "country" kitchen has played on the yearning for the rustic, down-to-earth hearth. But why does it always have to be so "Little House on the Prairie after The Long Winter"? Distressed farm table, dried things hanging. Whither the cheerful country kitchen? One that makes you whistle a sunnier tune.

Reality

Good morning, children! Open those windows and let the morning shine in. Breathe in the bracing air from the Alps—*aaah!*—and pretend you've been visited by Julie Andrews, or one of those musical nannies that swoops into a house darkened by sadness, and would first off hang cheery curtains, then go about fixing the family back up.

Take down every one of those dusty, dried chilis, Liesl. Mother Nature has a brighter palette! Sunflower yellow, blue-bonnet blue, tiger-lily orange. Everybody, get your Tyrolean hats! We're going to town to buy floral wallpaper in prints of all sizes. We'll let them run rampant like in a proper English garden. We'll cover the walls and cabinets, everything, with

92

Furniture EMS

Wood Veneer Cabinets: *Meaning they're cheap wood covered in even cheaper wood. Burn them—with a wood-burning kit. Emblazon the dull cabinets with your slogan du jour. Live well, laugh often, love much. Pass the Pepto-Bismol. Your initials: IR + CR 4E.*

bloomin' wallpaper. Maybe there'll be enough left over to make play clothes. Paint the ceiling, the counters, and all the horizontal surfaces (*and* the window trim, Marta!). Yes Gretl, lilac to match the bush out back. Ground the floral frenzy with a hardwood floor, stained a solid tree-brown. *These are a few of our favorite things.*

When the frost bites, we'll give it a cozy feel, warm it with toaster cozies, blender cozies, and microwave cozies. Chair covers, a padded table, in a quilted floral print, too. Now that everything's fresh as a daisy—pot one right in the center of the breakfast table. Ooh, look, here comes Father. Bring back those wood farm chairs with the straw seats and act as if nothing's changed.

Word from the Wise: *Charlie Trotter*

In great restaurants, the top table in the house is in the kitchen—the Chef's Table. Patrons pay extra to eat in the eye of the storm because the pros know how to organize a kitchen so it feels squeaky clean, super efficient and like a fun place to hang out. Charlie Trotter, chef and owner of Charlie Trotter's Restaurants in Chicago (right next door to Cynthia's store!) is one of them.

Small trash receptacles: *In a couple of different places, preferably concealed. One, built into the counter, is a perfectly neat rectangular opening with a lid. As the cook's working, she can push everything into the hole and it disappears. Better not to have to go marching over to single large receptacle but to use a bunch of little ones.*

Space savers: *Like a mini-wall that slides out next to the refrigerator, vertical storage makes it much easier to alphabetize your rack.*

Burners, baby, burners: *Two sets of burners let the hostess have two different things going on at once. Unsightly cooking of stocks and such on one, more fun things like having friends help sauté a little something on the other.*

Fantasy island: *In the center of the kitchen, a marble-topped island where guests can hang out and watch or help with the pretty work, rolling pasta, or plating the dishes. Below it are two refrigerator drawers, one for wine, the other for cut meat and fish.*

Cabinets with glass faces: *You know you have this stuff in the back of your mind, but you never know where it is, and often forget what's there. But if you see the swan-shaped martini glasses you'll use them. Maybe to serve caviar.*

Outlets around the kitchen: *Even inside the backs of cabinets. Mobility is key!*

Restaurant-strength dishwasher: *Where you can do a whole cycle in sixty seconds. Not that much more expensive and at the high temperature of 180 degrees, you can also use it to warm plates.*

Distressed cabinets: *More forgiving to the hits and nicks which are for any cook inevitable.*

LEFTOVERS

A few scraps we didn't have room for.

Tin swans in a row: A flock of aluminum-foil sculptures inspired by the doggy bags they twist up for you at fancy steak joints.

Cabinet fever: Spruce up boring cabinet doors with decoupage, swap 'em for gingham curtains like they have at bakeries, or re-cover them with easy-to-sponge-off patent leather.

Anything but fake fruit: Japanese restaurant supply companies sell mouthwateringly real plastic sculptures of not just sushi but bowls of spaghetti, shellfish, steaks. Display your favorite meal.

Looking good: Mirrored splashboards around your sink?

Cutlery tray: Mounted on the wall for nicknacks.

Styrofoam cup chandelier

Striped linoleum floors

The wedge table: Fits into the corner and saves space.

Ask Swelloise

How to Keep a Butcher Block Countertop Clean and Fresh: *Scrape off all waste after each use; rub it with salt or a baking soda paste every now and then. To give a stainless steel sink extra sparkle—never use abrasive cleaners, but polish with glass cleaner or a baking soda paste. If it gets scratched rub it gently with very fine steel wool, then buff to a sheen with a soft cloth.*

CHAPTER SIX

Dining In

WHERE YOU ALWAYS HAVE THE BEST SEAT IN THE HOUSE

BISTRO CHEZ VOUS

The asparagus are simply heaven, Helen. You must have a marvel of a green grocer. I would have thought it weeks before you could find tips this tender, and the color! Pass the aspic, would you, Zeigfried?

Something weird happens to people when they're seated in stiff-backed chairs at a long table loaded with crystal. They start acting starchier than the exotically folded napkins. *It's supposed to be an Egyptian* felucca.

It's supposed to be a dinner *party.* Bons mots and innuendo, hotheaded political debates, spontaneous footsy, a **FOOD FIGHT,** something! The dining room ought to be the place where you have the best time, not where you're on your best behavior.

Keep in mind, this ain't the spot where you throw down a tuna sandwich while standing at the counter holding the car keys, either. The challenge: To make the space—whether it's a room that opens up with double French doors or just a couple hundred square feet of living room—special enough for special occasions (heck, you're cooking, the occasion is special), yet totally relaxed. All the fun and glamour of going out—but *chez vous.*

Bring home a style doggy bag from your favorite restaurant. A giant velvet banquette below a mural of chubby nymphs like they've got at Café des Artistes. The twinkling Italian lights that brighten up the garden terraces at the Hollywood hangout The Ivy. Blackboard walls from the bistro where you cap a swell night with red wine and steak frites. Pillowy couches for spreading out the hookahs and the hummus, if that's your feed bag, baby.

Ideas of elegance have relaxed. When going to a gala these days, you can get away with T-shirts and ball-gown skirts. The formal dining room should take a chill pill, too. Skip straight to the part of the evening when the black tie is unknotted, the girls are wearing the boys' jackets, and everyone's jumping into the fountain.

Set the let-loose tone in your canteen by flouting a few rules yourself. And ask impertinent questions: Why do chairs have to match? Why does there have to be just one table? How about a romantic dining table for two—on wheels? It rolls about like room service from the best view in the house at sunset to the—OOPS, THERE GOES THE ASPIC!

"pass the salt, miss jones..."

Scheme 1 | *Power Lunch Room*

Dream

The friends and family are coming over! You want everyone to feel like a hotshot, a first-class fat cat, a big deal. Set up the mogulettes and future CEOs at your private executive dining room. A place where the surfaces gleam with expense account good taste, and after the first three courses—make mine on the rocks—all the company is ready to sign. Bonuses for everyone!

Reality

For that three-martini-I'm-hitting-the-glass-ceiling feeling, use steel, glass, and chrome—lots of captain of industry materials. Make bold moves. Be decisive. Invest in a long, long table big enough to accommodate the whole board in some super-laquered, burled wood that looks like it's been illegal since the Taft-Hardy Act.

"who is this...?"

salt

But won't that be hard to find?

Excuses didn't build this company, son. McGee, any ideas?

It can be easily manufactured, sir, I mean, ma'am. Find any table with nice legs, apply a wood veneer, and add a few inches of shellac.

Nice work. Executive watering holes always invoke the forces of Nature: wood, metal, and water. You'll need a fountain. Buy a ten-foot length of copper gutter and have the ends capped. It's a reflecting pool. Indoors, it won't turn green. Toss pennies in and wish for luck on your next merger or acquisition. Heh, heh.

Surround the table with cushy office chairs on casters for rolling to the mashed potatoes. Tell your assistant to have them re-covered in white leather, a these-boots-are-made-for-walking power look. The windows have beaded curtains, like at the Four Seasons restaurant (made of pop chain, the stuff used as pull cords for ceiling fixtures that you can buy by the yard at any hardware store). On the wall, mount display shelves in different lengths in some other rich-looking wood, to exhibit your collection of single malt scotches, brandies and eaux-de-vie. On the opposite wall, hang an oil painting of the chairman of the board. Change it every time you invent a new company.

THE *12* CHAIRS

As a swell hostess says, it's not what's on the table that counts—it's what's in the chairs. Or, maybe it's just the chairs. They don't have to match but pick them with care: comfortable enough for endurance eating, or just good-looking. Bone up on the classics. As a defining element of a period, chairs are the one thing in decorating people always reference, so it doesn't hurt to be able to throw around the lingo when you find yourself serendipitously seated next to Mr. Available Architect.

1, 2, 3 LOUIS, LOUIS...LOUIS?

Three French kings whose penchant for furniture still influences the bourgeois palaces of today. Basically, the Louis' got more and more delicate as they got more decadent until the French Revolution put a stop to them. What's the diff?

LOUIS XIV (1643–1715): Baroque and masculine. Massive pieces with straight lines, broad backs and seats. Enough carving and gilding, tortoiseshell, ivory, and mother-of-pearl to be worthy of Versailles palace and the Sun King who built it.

LOUIS XV (1715–1774): Monsieur Rococo. More feminine but still heavy, like a dowager who wears lots of powdery perfume. Every device employed to detour the straight line into a soft curve. A completely upholstered armchair with closed sides, the Bergere, with its low center of gravity and squat, rounded legs, is the only comfy period chair. As easy as a shepherdess, which is what bergere means in French.

LOUIS XVI (1774–1792): By the time he rolled onto the throne, aristocrats were tiring of froufrou and returned to classics: chairs with little padding, carved arms, slim, straight legs suited to a gamine princess. Hence the fauteuil, a chair with open back and arms. Youthful and hard, like Marie Antoinette.

HEY, QUEEN ANNE, NICE LEGS!
(1702–1714)

Chairs inspired by the eighteenth-century English queen have wooden backs with undulating splats (the piece of wood that goes up the back, like a T-strap on a shoe) and amply upholstered seats. They're best known for their gorgeous gams. These are cabriole legs, to be precise. Curved at the top, they taper inward like the legs of a cantering animal, sometimes even ending in a hoof. Maybe it's sexier to think of a ballerina leg, because a cabriole is also when a dancer lifts one leg in the air and whips the other up to meet it. Hey, take a picture, it lasts longer!

CHIPPENDALE
(MID 1700s–EARLY 1800s)

A synonym for the crowd that prefers Sotheby's to Ikea, but Thomas Chippendale was just a cabinetmaker. No reason to be so intimidated. His specialty was fancy woodwork, only in the richest mahogany. Inspired by many styles—Gothic, Chinese, French ribbon back—some of his early pieces had cabriole legs and claw-and-ball feet. Made primarily in mahogany, these expensive, heavy pieces do their best to create an old-money mood around the dinner table. So if you're sitting in one right now, elbows off the table, and please remember we spoon the soup away from ourselves—perhaps to avoid spilling on the Chippendale.

WINDSOR
(LATE 1700s–EARLY 1800s)

These classic American chairs were actually introduced in England, at Windsor Castle, but became popular during the American Colonial period. The name applies to any kind of wooden chair with vertical rods, called spindles. If the top is rounded it's called a hoop back, the kind in Robert Edge Pine's famous painting of the signing of the Declaration of Independence, where you can see the founding fathers taking a load off.

DUNCAN PHYFE
(1790–1856)

A transplanted-from-Scotland New Yorker and America's first great furniture designer, he developed the Federal style. The French Directoire influence is visible from all the Frenchies who came here after their own revolution. Lyre motifs in the backs and lots of eagles—patriotism was big back then. Mahogany was the preferred wood, suitable for Betsy Ross (and later Diana!).

103

SHAKER
(EARLY 1800s–EARLY 1900s)

Shaker dolls don't have faces, which should give you a sense of how they feel about decoration. They believed plainness was next to godliness. These are the chairs you might imagine Laura Ingalls Wilder in: functional and straightforward, made from pine, walnut, maple. They're simple but cheery chairs with slatted backs between two round posts (adorned with nothing more than an egg-shaped finial). The seats are cane, so if it's real Shaker, they've probably been replaced a few times.

9 VICTORIAN (1800s)

Large and clumsy, quaint but considered poor design. The Victorians, despite the queen's staid image were trend gluttons. They provoked revival after revival, and came up with a hodgepodge of every style that preceded them—Gothic, Louis XV, Greek, and Roman motifs—in heavy woods like black walnut and rosewood with demure skirts to hide the legs. Honestly, they seem like old crazy-lady chairs—Mrs. Havisham meets Mother Bates. But, no, we really like them.

MISSION
(EARLY 1900s)

Your Mission chair, should you choose to accept it, will be a combination of leather cushions and wood. If it's all wood, it'll have a back shaped like a sideways H resting between two square posts. It will probably be a copy of a design by Gustav Stickley, the granddad of the movement. At the time, knockoff artists made similar styles, claiming that they were based on pieces found in California's missions. Only the monks know for sure.

MIDCENTURY MODERN
(1920–1970)

As architects started designing furniture, it became less about ornamentation and more about materials and aeronautics, almost a contest. Who could keep bums aloft with the cleanest lines, the most innovative, biomorphic shapes, and the elimination of nonessential detail?

So many greats to choose from. Ludwig Mies van der Rohe kicked the competition off in 1927, reducing the chair to two elements: leather and steel. His low-slung, armless Barcelona chair is sleek, strong, and sticky if you happen to be wearing a miniskirt. In 1946, Charles Eames used the exciting new postwar material fiberglass to mold a shell-like seat that became the model for airports and classrooms and could even make squirming comfortable. Harry Bertoia, a sculptor by trade, went to work for Knoll International and in 1952 unveiled a line of outdoor seating that looked so good people couldn't wait to bring them in: curved meshes of gridded wire coated in colored vinyl or chrome, with little cushions in vinyl or cotton. And who could forget Arne Jacobsen, the unmelancholy Dane whose 1955 stacking chair curved plywood into a piece of bow tie pasta served on chrome legs? The chair was immortalized when the ˙sexpot mistress Christine Keeler of the Profumo affair, a political sex scandal that shocked Britain in the sixties, posed nude straddling one. With the flared back barely concealing her—well, let's just say the chair wasn't the only thing that was stacked. Another curvaceous item that has never gone out of production is the tulip chair, designed by the

Finnish architect Eero Saarinen in 1956. Its legless, white fiberglass pedestal base is Saarinen's trademark—picture milk spilling into a puddle. Lastly, Verner Panton, the mad Danish genius who approached furniture like stage design. His cantilevered S-shape (1960) was the first one-piece plastic chair, according to the Museum of Modern Art. Panton did those curvy chairs made from a single piece of molded plastic that conformed to the shape of your body. Some are still in production and inexpensive, like the one shaped like a dog bowl. The sturdiness of his elegant S-chair was proven by his wife, Marianne, in photographs that showed her perched on the tip of the chairback sipping champagne.

BELLINI (1998)

With a name like Bellini you think frothy, sweet, and peach colored. But no, the straight-backed, four-legged, no-frills chair by Mario Bellini is made of one piece of molded fiberglass-reinforced polypropylene. Armless, light, and stackable, the Bellini fits in anywhere, and more than one won't give you a hangover.

Scheme 2 | Bistro O

Dream

Jackie Kennedy made her name as a legendary hostess by transforming the White House's dull-as-consommé state dinners into a whirling hub of fashionable society. One key move was switching from the standard long banquet table to a series of smaller round ones. Genius! Guests could have more intimate conversations and table hop as if they were in a small elegant bistro.

Reality

Love the idea of round tables, but, with all due respect to Sister Parish (Mrs. K's decorator), we had a hankering for something more nouvelle cuisine than the silk shantung stretched across the Louis XVI chairs of Camelot's dining quarters.

So make it less Jackie, more O! Round tables and...polka dots!

Pick up a few different-size round bistro tables at a restaurant supply store. Paint one white, the other two...hmm...orange, since the color is said to increase appetite and was Frank Sinatra's favorite (wasn't he once a Jackie escort?). The tables themselves are dots. Jackie was a mastermind of elaborate seating plans and charts. Put your own spin on dynamic seating arrangements with swivel chairs, so guests can twist and turn to the conversation at the neighboring table. If it's too hard to find a whole swivel set, collect swivel chairs in all shapes and sizes. Cover each

new acquisition in the same orange polka-dot fabric, so no one really notices that all the chairs are different.

Hello, taste police?

To keep the cheeky dots chic and not cartoony, temper the eye-popping pop with some grounding touches. Clean earth tones. Bleach the floors to a pale shade of peroxide blond. A bone-colored paper with a natural texture on the walls. That'll make it kind of Danish, more sophisticated. Garnish the look with fruit bowls on each table filled with oranges, and, because it's a Jackie tribute, cool, oversize shades—on the window—that when pulled down show a big orange dot.

Orange you glad we didn't say banana?

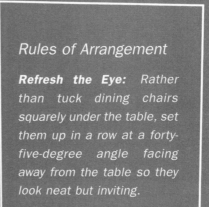

Rules of Arrangement

Refresh the Eye: Rather than tuck dining chairs squarely under the table, set them up in a row at a forty-five-degree angle facing away from the table so they look neat but inviting.

Furniture EMS

Guess Who's Coming to Dinner? Remember on Bewitched *when Darrin would announce at the last minute that his boss, Larry Tate, was coming to dinner? Samantha didn't blink—she just wiggled her nose. When you need to dress the room to impress, whip up your own fashion magic. Ransack your Big Night linen closet stocked with a few fashion-forward accessories to elegantify the room for a night off the town. Satiny, Chanel-quilted slip covers. Seat cushions made from beaten-up leather logo bags. Status scarves Mom said you'd appreciate someday. Fold them at opposite corners, then into a band, and knot them around the chair back, like they do at weddings. Pin brooches on the linen napkins.*

Ask Swelloise

How to Remove Hardened Wax from Candlesticks: Place them in the freezer for an hour or so; then peel off the frozen wax, wash the candlesticks and dry them. Scrape candle drippings off the table with a plastic spatula. Rub remaining wax into the wood of the table with a soft cloth.

SO BAD IT'S GOOD: *Mounted China*

Okay, those Franklin Mint collectible dishes on the wall may be a concept with a few chips, but the brackets have potential. Cover a whole wall with them, ordered from the Vermont Country Store catalogue, and store all your plain white dinner plates for a porcelain "tiling" effect. When your fancy strikes, mount the fruity china with gold trim you inherited and never unpacked from the padded china bags. What seemed frilly on the table looks wild on the wall, coordinated with that striped wallpaper.

Scheme 3 | *Dining Lounge*

Dream

Life is a buffet. Better yet, a happy-hour with chicken fingers and popcorn shrimp amid tinkling cocktails and crepuscular light. Now that we're getting to know each other better, Kip—may I call you Kip?—the truth is, once you sit down to dinner, the evening takes such a sober turn. Everything gets so heavy. Tuna hunk or lamb shank? I'm more in my element feeding like a lounge lizard, free to get up and move around, sit Indian style if need be, peck at bite-size bits of tuna tartare, caviar, tiny teacups of chilled pea soup. I like to keep things light.

Reality

Hey, thanks for sharing. To deal with your dining dis-order, create a zone where cocktail hour blends seamlessly into the rest of the night, a space where meals have no beginning, middle, or end. People come and go and are never late.

Proclaim your lounge the Ottoman Empire. First carpet the floor in a shag as blue as Ataturk's eyes, and let the carpet climb up one of the walls, just like they used to do at clubs in the sixties and seventies. And, come to think of it, at the Kenny Scharf Room at Area in the eighties, where—it's all coming back—panels of carpet alternated with panels of mirror. Along the carpeted wall, park a row of carpeted cubes scattered with bold print pillows that spill onto the floor. Low seating is the priority. You could have a cabinetmaker create the cubes out of MDF, or medium density fiberboard. The ottoman cubes can be pulled or pushed over to the

nearby seating group: a constellation of snack-size cocktail tables, love seat, and comfy chairs to hang out in till two in the morning. Keep the lighting low, too. Literally. Set off the lounge area by hanging a row of three, four or more pendant lamps in aluminum or

Word from the Wise: *Verner Panton*

Swing Along: *"I can't bear to enter a room and see the sofa and coffee table and two armchairs, immediately knowing that we are going to be stuck there for an entire evening. I made furniture that could be raised and lowered in space so that one could have a different view of the surroundings and a new angle on life." In 1963, Panton designed the flying chair, an upholstered lounge curved like a banana, which was hung from the ceiling on cables and could be raised or lowered by a pulley block. Panton arranged the flying chairs in groups to create an environment of flying sofas, where the users could communicate with one another and set one another swinging.*

colored glass. Place them as low as they can go, maybe two feet from the floor, a move of Verner Panton's, a high-livin' god of sixties lounge design.

Raising the Bar

Rick: Swello, I'm Ilene's boyfriend. And Cynthia's friend, too. Which is why I'm allowed to make this special guest appearance in my own anecdote. You see, I'm the kind of guy who spends a lot of time reading shelter magazines (instead of watching football). You could say I'm a GSM—a gay straight man, but we don't like to be labeled.

Speaking of labels, I'm a firm believer in a house having a bar. No liquor in kitchen cabinets. What, you're gonna have a bowl of scotch for breakfast? A proper bar with glassware and hardware (corkscrew, opener, shaker) and as many kinds of liquor as you can afford.

My "concept" for our house in Sag Harbor was ambitious. Floor-to-ceiling shelves, cupboards, backlighting, and a drop-down "Murphy bar" in rosewood to match our sixties hi-fi cabinet. I took these plans to a furniture designer. He came back at me with drawings and an estimate: $5,000. I paid him for his time and went back to my bulging design file, where I found a clip on Rakks shelving—a poles-and-brackets system used for storing everything from library books to medical supplies.

My literary hero Kingsley Amis, on the cover of his book, On Drink poses in front of a glass-front bookcase stocked with every kind of booze known to man. That was what I wanted: a well-stocked bookshelf-bar.

I called Rakks. They sent me to a place on the Upper East Side called The Shelf Shop. I bought three poles in brushed aluminum and seven white-laminate shelves, six feet long—for $500. A couple of hours of obsessive measuring and leveling later, we had our bar—short shelves for the glasses, tall ones for the bottle of Czechoslovakian absinthe, and mediums for the swell tomes. I could go on, but I've got some "reading" to do.

ALCOVES

The tight, often windowless space is a design challenge. People think there's not enough room to do anything cool. To make it look bigger, classic design books sometimes suggest a perspective drawing of a scene in the background—like a 3-D mural of the canals of Venice. *Hmmm.* We're seeing a few simpler optical illusions.

Have Fewer People in There

A small space with someone you like isn't claustrophobic, IT'S ROMANTIC! Turn the alcove into the "booth in the back in the corner in the dark." You know, the one that always has the RESERVED sign on it. Monopolize two of the three walls by putting in an oversize banquette, wide enough for lying back and being fed grapes. Cover it in violet velvet or your best *Color Me Beautiful* color. Along the back put pink accent tube lights, the kind more often used under the dashboard in hot-rod Corvettes (they *can* be adjusted to flash to the music). To leaven the heavy-petting vibe, hang your collection of framed cute dog photos. AND THEY CALLED IT PUPPY LOVE.

If You Can't Widen the Room, Open Up Some Vertical Space

Nana's great oak dining table dates back to the day when you were sitting on telephone books to reach the lasagna. The lion's claw feet are still scary. "But it's an antique." Throwing it out would surely bring a curse upon your head. You'll get off easier with committing second-degree furniture-cide. Get a Japanese pull saw at a hardware store. It will cut through anything, and saw the legs in half—you're halfway to Tokyo—and it's a tatami room. Give the old girl a

nail-lacquer-red paint job. Lay down some tatami mats and, on top of them, place seat cushions in Japanese silk prints in Kabuki white, true red, and eyeshadow aqua. For lighting, the obvious choice is paper lanterns. So don't go there. Bring the look into this hemisphere with some low-hanging midcentury modern glass lamps in yellowtail and other sushi colors.

Defy Gravity

To create an aura of airiness in a small space, design mavens often suggest furniture with slender legs. Well, how about furniture with no legs! In this

Word from the Wise:
Thomas Jefferson

The Founding Father was also a design pioneer. He invented the first swivel chair, the lazy Susan, and the dumbwaiter. Monticello, his Virginia manse, had thirty-five rooms, yet Jefferson still economized on space. He had a bed that could be raised and lowered on pulleys so the area could be used for purposes other than sleeping during the day.

room, to create a feeling of space—and suspense—everything's suspended. The room's centerpiece is a legless table, a slab of wood with four holes drilled for cable wire that then runs through a pulley on the ceiling. It can be lowered to bar level, dining or after-dinner coffee heights. Everything else in the room gives a feeling of gravity defiance, too. A clear glass shelf works as a nearly invisible sideboard, holding up pitchers of Tang or whatever you're serving. For extra credit, call your cute contractor and have him cut baseboard windows that run along the wall at floor level, exposing the ground outside. They give the room a feeling of floating. After dinner, the chairs get pushed to the side, the table is raised flush to the ceiling, and down come the banana chairs.

Divide and Conquer

Gentlemen! And, er, ladies, unfortunately, we have to come to terms with the fact that without the luxury of a separate dining room, we have no choice but to *colonize* a patch of real estate in the living room. Follow my pointer on the map! We must create a room within a room. The key to victory will be to allow the space its own identity, to suggest borders without choking off resources. This will require subtle politics. Rely on an Oriental area rug curling at the edges and it will get no respect. We'll consider our options over some port. Cheers, cheers. Let freedom ring.

A patch of cherry wood area paneling on the ceiling covering the area above the table and chairs.

A woggle of wall-to-wall carpeting that's adhered to the floor and finished in a nice metal trim.

A partition of paint to mark the dining zone; let the brush marks show to take the edge off the edges.

A deck of cards—why not, if you've already got that green felt poker table. Make the makeshift eating space feel like a big spender's spot. Cover a portion of the walls where they meet in the corner in charcoal felt, the color of Paul Newman's suit in *The Hustler*. Scatter a deck on the floor and varnish them face up, all fifty-one; number fifty-two goes on the ceiling— just because it's fun to shrug and look baffled when someone asks, "How'd that get up there?"

CHAPTER SEVEN

Smooth Transitions

HALLWAYS, FOYERS, DOORS, AND WINDOWS KEEP
A SWELL HOUSE ON THE MOVE

Chewing Up the Scenery

The things that stick with you most on a road trip are often the pit stops, the tiny back road with an amazing view you hit on your way to somewhere else. Same logic applies when you stay home. Destination rooms get all the attention, but a swell decorator knows not to ignore the action in the journey—the hallways, foyers, stairways, and other just-passing-through spaces.

After all, these little inconsequential in-between places are often the setting for dramatic moments. Grand entrances and exits. Big hellos, tearful good-byes, door-slamming rows!

In movies, divas have their blockbuster moments in stairways. Norma Desmond making her final entrance in *Sunset Boulevard*. Bette Davis tossing off her best line in *All About Eve* ("Fasten your seatbelts..."). Everyone remembers the red-carpeted stairs Rhett Butler carried Scarlett O'Hara up in *GWTW* (not to mention the moment when she tears down the drapes to turn them into a dress).

Setting the stage for your own Oscar-worthy scenes isn't hard. Expectations for these spaces are so small, anything you do will get big reviews. Go ahead and try something silly or extravagant. Dress the windows like they do at a head-turning boutique. Turn the hallway into a hall of fame. Or just get that pink Carrera marble that costs "a fortune" (except when you're only ordering ten square feet for the entranceway), and look like you've really arrived.

FOYERS

In the Gilded Age, when visitors were "callers" who stopped by for tea and a recital, architects considered a house's entranceway to be central. They were grander, with crystal chandeliers, consoles giddy with whorls, musician monkeys on porcelain elephant stands and other impressive stuff. Those were more leisurely times. As the century wore on, people started looking at this big, open room with no particular purpose as wasted space. Heck, you could fit a whole home office in there! And so the foyer waned, a neglected stepchild, shrinking, becoming more cramped, a dumping ground for umbrellas and shopping bags.

Time for a revival.

After all, the foyer is the opening number of your show. On a date, it may be the only room a guy ever sees. First impressions! DAZZLE 'EM when they walk through the door, then the rest of the house is cinchy.

Knock, Knock...
Hue is it?

The simplest solution to giving a foyer a colorful identity is to paint it all one color.

Back to the fuchsia: *How nice to come home to a pipe-and-slippers situation, minus the pipe. Paint the walls to match the toasty pink in the paisley of your new favorite robe, and put down a pink broadloom area rug to match. Allow an eight-inch border for the parquet to show through and give the eye a rest. The only other elements in this indulgently pared-down room are a hook at eye level and a shoe shelf. When you come home, swap the coat for the robe, the shoes for the slippers.*

Aluminum paint: *With a Vespa parked inside, ready to peel out.*

Lemondrop yellow: *Color therapists say it makes people salivate. Put big glass jars stocked with penny candy on a "gummy-resin" shelf, custom made from expoxy resin, a transluscent material in gummy-bear colors.*

Green room: *That's what they call the rooms in TV studios where stars hang out waiting to go on air. Blast the A/C, like Letterman does, and put out lots of fruit and cookies and other high-cal energy uppers.*

Blue note: *Lay a flagstone blue floor and hang album covers on the wall of Miles Davis's* Kind of Blue, *Billie Holiday's* Lady Sings the Blues, *and any other heartache greats.*

COMING-AND-GOING ATTRACTIONS

Placate people who are waiting for you to finish putting on your makeup with something to amuse them. It could be an absorbing painting or an interesting chair. Anything but a clock.

First-class Lounge

Rush-hour insanity. It boosts your mood to catch a whiff of vacation on your way out the door. Hunt down a row of Eames fiberglass shell seats, three or four attached to a single metal base—they used to be in airport lounges but are now often lying around architectural salvage shops. A stack of retro suitcases forms a table. On top is an open vanity case and mirror to chuck your keys and check your lipstick. Don't forget the wall calendar with the days crossed off till your next flight out.

Graumann's Chinese Foyer

Putting out a guest register to sign, like they do at B&Bs, might not feel like the freshest idea in the book. So get rid of the book. Put up a mirrored wall made of that worn-looking mercury glass, and have each visitor leave a lip print and initials in his or her best shade. Hang a "Been There Done That" gallery: snapshots of your guests all doing the same thing—singing at the piano or just walking in the door as the oddball director John Waters does. Cynthia used to snap her visitors midair on her trampoline.

Weather Station

Dig out that spare TV from the garage, mount it in the corner, and keep it tuned to the Weather Channel. Show off your umbrella collection. Underneath a slatted bench, line up a bunch of bright yellow galoshes and extra large Wellingtons, big enough to store all-weather gear. On the back heels of the boots where the kindergarten teacher would write "Johnnie," mark "Hats," "Mittens,"…and so on.

Ask Swelloise

How to Keep Water from Collecting in the Umbrella Stand: Just cut a piece of sponge to fit inside the stand's bottom. Remove and squeeze the sponge dry when necessary.

FLOOR SHOW

Because there's generally not much in the way of furniture in the foyer, it's the floor's shining hour! Give it some *oomph*. Universities have the alma mater's crest inlaid in the entrances of the big lecture hall. Paint or inlay your floor with your insignia, whatever that might be. Sign companies make metal pieces that can spell out your catchphrase ("Hi ya," "Ciao," "Cheers!"), and floor companies carry all kinds of stock medallions that they can easily lay into the hardwood. You can find circular parquet designs that look like a meditation mandala, a horse's head, a skier, and custom medallions, too. Animals are always good: a mahogany portrait of Farrah, your golden retriever, a bear or a bull if you're a sports nut from Chicago, a fox if you're swell. But be sure to keep the crest a few feet from the door since it's bad luck to step on it.

The R&R Historical House

Maybe Thomas Edison didn't live here, but you do. Declare your house an HISTORICAL LANDMARK. And, like at any decent historical landmark, make the first room a museum of sorts, an overview of the site. Frame the survey, photos of the house, put the architect's model of the garage renovation on display, as well as any artifacts found on the property.

WELCOME ◆ WELCOME ◆ WELCOME ◆ WELCOME

Built-in Swellcome Mat

Cynthia: I always like to leave a welcome message at the door for my customers when they come to visit. We have a built-in WELCOME/THANK YOU mat on either side of the entrance of the showroom. The words are set in aluminum in the floorboards. At the downtown store in SoHo, the same thing is "written" with nail heads. In Tokyo, the CR store has a hopscotch board laid into the concrete so customers can hop inside. Cute, so long as they don't try to skip out.

Who Says... You Can't Fake a Foyer?

Something about walking through the door and finding yourself—*bang*—in the middle of the living room. It seems so abrupt. Like a book without an introduction, a meal without an *amuse-bouche,* sex without foreplay (okay, that one's not always so bad). Still, a house needs a prelude. When you live in a one-bedroom flat that's been chopped out of a Classic Six,* where two rooms and a bath is all you see and all you get, create the illusion of an antechamber, a place to check the mascara and your coat before exclaiming, *"J'arrive!"*

To create the feeling of an enclosed space, have a carpenter put up *a partial wall* opposite the doorway with drywall, or set up *a free-standing shelf unit.* Fill the shelves with handbags, hats, the video you have to return. The back of the unit is now a blank surface to hang a painting, a photo, or something more fun to stare at than the door. Even easier, *hang a mirror* from the ceiling over a half-moon console that would be flush up against the wall—*if* one were there.

✱ CRIB NOTE

Classic Six Apartment *Usually refers to a prewar apartment built back in the day when it wasn't decadent but merely civilized to have a six-room dwelling: a living room, dining room, kitchen, two bedrooms and...a maid's room!*

Stairs

12-Step Program

Jacob's ladder. The steps at the Palais des Festivals at Cannes. A staircase is a metaphor for grand ambitions, aspirations, your climb to the top. So fix yours up, up, up!

1> Slide banister: *When kids see steps, they don't go, "Oy! I gotta climb those?" They see a place for scrambling up and sliding down. You're not too big for such behavior, you just need to install an extra-wide banister to slide down. Wheee! Give it a few coats of enamel paint to pick up some extra speed.*

2> Showrunner: *From the Ziegfeld Follies to Caesars Palace, showgirls always do the big number on a grand staircase. You don't need a feather head-dress to make your big entrance, just a fabric runner on the steps—your own version of the red carpet, in red wool glued down and held in place with brass carpet flanges.*

3> Upsy-daisy: *A really simple idea for making steps come alive that we saw in a party-supply store in Tokyo (don't ask) was to decorate the face of each step with photo-realistic Contact paper of climbing pink roses. Take it deeper: paste on 3-D aquatic backgrounds used for fish-tank scenery, swimming with coral reefs, shimmering fish, and the occasional mermaid. Like you're walking on water.*

4> Step by step: *Conceptual artist Jenny Holzer created* Ceiling Snake, *an installation that consisted of a staircase over which hung a moving message board like a tickertape that ran one thousand sayings and truisms written in those little red LED lights: IN A DREAM YOU SAW A WAY TO SURVIVE AND YOU WERE FULL OF JOY. Something lighter? Stencil the face of the steps with an inspiring line from the Three Stooges' bit: SLOWWWLY I TURNED, STEP BY STEP, INCH BY INCH...NIAGARA FALLS. Hey, it's only funny till somebody gets hurt.*

5> V.I.P. railing: *Replace the banister with velvet ropes, like they have in front of tough-door nightclubs, with the brass stands bolted to the stairs.*

6> Stairway to heaven: *In the Bible, Jacob tried to build a staircase so high he could reach heaven. You'll be content with cantilevered stairs, individual steps that project from the wall. You're walking on air.*

7> Bookcase steps: *A bookcase whose shelves are staggered so that the longest shelf is at the bottom and the narrowest at the top, creating "steps." Pick up an old Penguin classic as you climb up to your loft bed.*

8> Secret staircase: *Replace the banister with something that encloses the stairwell, a Moroccan screen, bamboo poles, stainless steel poles, or for fun, oversize baluster shapes cut from flat boards of lumber.*

9> Coat rack at the top: *At the fabled Fontainebleu Hotel in Miami, in its 1950s heyday, ingenious interior designer Morris Lapidus put a coat rack at the top of the lobby stairs rather than in the more customary spot on the ground floor by the doors. That way, swell guests could take off their coats and freshen up before making a real wow entrance. Why they were wearing coats in Miami in the first place is another question for another day.*

10> Footlight fever: *Install motion-sensitive lights, the ones in ritzy driveways, at the top of the stairs that activate every time you make your ascent. Ta-da! Or implant tubes of the red footlights that run along the carpet in movie theater aisles.*

11> Shelf life: *Remember how Mom used to leave chore notes, all the stuff you had to carry up to your room, and other delights you shouldn't miss on the steps? Thanks, Mom. Leave stuff that's more fun to look at: a painting leaning against the wall or vintage shoes that were a-dor-a-ble—but the wrong size.*

12> Nude descending a staircase: *Influenced by Duchamp's dizzying Cubist painting, refinish the not-so-terrific wood stairs by sticking down a variety of overlapping wood-grain shelf papers or Contact paper, cut into funkadelic shapes and strips. Careful, don't pull a Gerald Ford.*

Oh Yes, You Do Do *Windows*

Sometimes a balloon curtain just isn't enough. Climb out the window of your imagination.

ROOM WITHOUT A VIEW

Every picture window doesn't tell a story. If yours looks out onto the Dumpsters, or the nudists' retirement home, re-*view* the situation.

A private screening: Rather than shades or curtains, use something more permanent and decorative that blocks the bad view and lets in the good light. Anything big and flat can be mounted on sliding-door hardware: shoji screens, lattice screens, a painting. Or just lean colored Plexiglas against the window so you look at the brick wall through rose-colored glass.

"Put a window where a window ought to be," said Joan Crawford in *Mommie Dearest.* Sometimes they ought to be in unexpected places, like at foot level, running along the baseboard, so

Word From the Wise: *Hugh Hefner*

In the '60s, Hef hosted a TV show called Playboy After Dark. *It was a variety show that followed celebrity guests partying at his Chicago mansion, which was retrofitted for hijinx. He had pogo sticks for getting around, a fire pole for a staircase, and windows in the garage that peeked into the bottom of his indoor swimming pool so guests could watch girls doing the breaststroke.*

you can watch the world walk by like Laverne and Shirley did from their basement apartment. Other times there ought to be but a skinny floor-to-ceiling window exposing only a sliver of unexpected green or blue. These can be achieved without major reconstruction by just pulling the wood blind three quarters of the way down, or a privacy sheer almost all the way across.

Tempera the glass: Remember how much fun it was to paint pumpkins and turkeys on the windows with tempera paint in kindergarten? Get left back. Dig up a T square and a triangle, and come up with some spontaneous geometric patterns like Frank Lloyd Wright did in stained glass. The beauty of your medium is that mistakes and bad drawings wash off with soap and water.

The Glare Witch Project

Ilene: As much as I love my boyfriend, Rick, for who he is as a person, I admit that one reason I decided to shack up with him was what he calls his apartment's Sweet Smell of Success view. Giant windows that look right up Madison Avenue, all twinkling red taillights. The Empire State Building appears close enough to dust. So as not to lose an inch of skyline, he has no curtains or blinds. Cool. Except when you're trying to sleep past five in the morning, and his crib lights up brighter than a dentist's office. One fitful morning, I snapped: "We've got to get some shades!" And so we did, eyeshades pinched from a Swissair flight. We slip 'em on like a couple of fading movie stars and leave the windows alone.

COUNTERINTELLIGENCE

If your kitchen window looks out to the backyard, build out the sill so it's as wide as an ample shelf, and put a couple of stools underneath. Then when you open the shutters you've got an outdoor lunch counter.

Draperies and Curtains: What's the Diff?

Draperies are made of heavier fabric, are lined, and are hung from hooks. Curtains are usually made of lightweight fabric, are unlined, and are hung from a rod.

Rules of Arrangement

When weather turns cold, allow as much sunshine into a room as possible. Light-colored curtains help keep a room warmer than dark ones because the former reflect sunlight back into the room.

Ask Swelloise

How to Clean Venetian Blinds*: Wash them in water and detergent in the bathtub. Rinse thoroughly and hang over the shower curtain to dry. In between washings use a blind duster, or wear thick, absorbent cloth gloves and wipe slats by "hand." To touch up soiled areas on white Venetian blind tapes, use liquid white shoe polish. Best time to wash windows is on a cloudy but not rainy day. A too-sunny day causes residual cleanser to dry too quickly and streak.

✻ CRIB NOTE

Why Are They Called "Venetian Blinds"? In 1769, the British designer Edward Beran enclosed wooden slats in a frame to adjust the amount of light let into a room. These became known as Venetian blinds for their early use over Italianate windows.

Ding Dong

DOORS OF SWELLVILLE

Knock knock! Who's there? Dishes. Dishes who? Dishes the police, we have you surrounded!

In a swell house, there's nothing wrong with occasionally coming unhinged.

Victorian pocket doors: *When there's no room for swinging, it slides right into the wall.*

Dutch doors with a shelf: *Tulips and wooden shoes. Good for* yoo-hoo*ing to your neighbors.*

What knockers! *A big brass lion's head looks doubly impressive on the indoor doors—the study, the bedroom, anywhere you want to make sure people knock loud and clear.*

Break on through to the other side: *Teenagers decorate their bedroom door with stickers,* KEEP OUT *signs, anything to warn passersby of the vibe inside. Hang a painting on the door, or two big-eyed Keane portraits of a girl and of a boy on the bathroom door, a brass plate like they have at restaurants engraved* BOUDOIR, BATH, COATS, ILSA'S ROOM. *Mount a wee shelf that holds a Polaroid of the occupant, like they have at all the best massage parlors. Or, so we hear.*

Slamming doors: *Leather upholstery buffers sound. That's why they use them in the boxes at the Paris opera. Or you could use homosote, a synthetic cork sold at the lumber store that buffers sound, doubles as a bulletin board, and can be painted the happy colors of grade-school classrooms.*

Cover a door in keys: *Adds substance to a cheap, hollow door.*

Letter slot: *In the study door. Pass messages to the workaholic in the family; "Dinner!"*

Porthole: *A yacht cabin, a T-bird window—round windows are sexy. You can get the kind they use in vans at the local chop shop.*

Restaurant push doors: *Odd doors with some history await at architectural salvage places. Cynthia found a black safe deposit vault door with the number 19 on it, thinking it would be lucky since she was on the nineteenth floor. Now her showroom rest room is very safe.*

Don't frame me in: *Door frames are so square. Color outside the lines like Le Corbusier did. When the Swiss-born master of modernism visited the Hamptons, upon arriving at his host's spread, his first words were: "Your house is very pretty, but it needs a mural" (only in French). On one wall, Le Corbusier painted a door that echoed the door in the room and outlined the actual door with broad black brushstrokes.*

KIDS IN THE HALLWAY

Corridors are inherently cool. You knew this in high school, but, uh, forgot. That's why people are always hanging out in them, loitering, misbehaving, leaning seductively against lockers. How come no one is hanging out in yours?

Hall of fame: They may not know you in Cooperstown, but in this neck of the woods you're all we've got. Make the hallway your own personal tourist attraction, where visitors get to know all your achievements. Put yourself on a pedestal by pulling out your childhood trophies gathering dust in the attic. Mount a shadow box holding the softball you pitched a no-hitter with in the Ladybug League. A framed Girl Scout sash full of badges hangs alongside the plaque you got when you were waitress of the month at Friendly's.

My way or the highway... Standing at one end of the hall and gazing down toward the other, it sort of looks—like a *high*way. Only when you're way high. Once the buzz wears off, you think, Hey, that might actually have been a good idea. Have that peaceful, easy feeling all the time. Pave the floor with glassphalt that gives off a sparkle: put down tar paper; the blacktop comes in premixed bags at the lumber store. Stick highway reflectors down the middle, or a painted white line.

> ### Word from the Wise:
> *Alvar Aalto*
>
> ***Hob-knobbing:*** *Chances are your place is outfitted with the cheapest doorknobs the contractor could get away with. Give them a twist, like Finnish architect Alvar Aalto did when he covered his in leather. Just a leather square wrapped with a lanyard. An oversize key hanging off it could be as cute as a tassel.*

Corridorphobia: Hallways can be scary. You never know what's on the other side of all those doors! It could be an angry poltergeist, those twins in *The Shining,* anything! Open up the dark hall by installing strips of glass along the side of each door, a look found in posh advertising offices on Madison Avenue. Put up a colored shade on the inside of each room's window—good for privacy freaks, and when drawn, they'll make cheery stripes down the hall. Now don't you feel better?

Shuffle off to shuffleboard: Rain, rain, go away. Videos. Yahtzee. You're going *out* of your *mind.* Cure your cabin fever with an activity on the lower deck. Sand the hall floor, number and line the court with cement floor paint and a stencil template that, along with the resort cues and tournament discs, can be had for less than the price of a plane ticket to Florida. And polyeurethane the hell out of it. shuffleboard@qwest.net

Dance floor: Spraypaint the floor with shoe prints like an old-fashioned dance diagram, a tango, a cha-cha, a fox-trot, a hustle, whatever your favorite dirty dance is. Let a few step-prints climb up the wall for Fred Astaire flair. A top hat on a shelf.

H-708.14: Remember college? The library stacks were hot. A place for sexy encounters. You know, perusing *Lady Chatterley's Lover* with the hope of bumping into that sexy grad student doing his Byron dissertation. If the ceiling's high enough, stow your books on shelves above the doorjambs, put in a Putnam rolling ladder, and organize your stacks by the Dewey decimal system. Just like our first lady, Laura Bush.

CHAPTER EIGHT

Indoors Out and Outdoors I

IN A SWELL DWELLING YOU DON'T KNOW WHERE THE HOUSE ENDS AND THE REST OF THE WORLD BEGINS

GIMME SHELTER—BUT NO WALLS

Boundaries? Save 'em for the shrink's office! On a swell estate, the walls that divide interior and exterior are permeable. That's why if we had to pick one room to live in for the rest of our lives, it would have to be a lanai. Originally, a lanai was a lush Hawaiian-style porch entered through sliding doors from the living room, giving a sense of unbroken living space. There's something glamorous—tropically paradisiacal—about not knowing where the house ends and the rest of the world begins.

The lanai concept is universal. The courtyard of a Tunisian villa, where candlesticks and Oriental rugs are on both sides of the lacey, filigreed doors. A safari lodge, where perched on a boulder in the library, guests sip cognac and watch hippos through the glass walls. Or one of those fabulous, sixties Palm Springs spreads that spills from the living room straight to the pool with everyone milling about in long

earrings and caftans. ("No, really, you *must* come to Madagascar! We're *all* going to see the solar eclipse.") Back then, they called it martini modernism. We *love* that.

Sadly, not everyone can have a true lanai—including us. But you can capture its spirit: the feeling of openness, the balmy sophistication, the expansive sense of possibilities. A lanai is a state of mind. So hold on to the mental picture of the infinity pool out back and the palm tree poking through the roof when you plan your oasis.

Whether an urban terrace or a deck in the 'burbs, the key is to create a sense of oneness, of *flow* between In and Out. It could be as simple as painting the deck and hardwood floor the same color, so it's hard to see where one ends and the other begins. Consider the backyard, the terrace, or roof an equal to any other room in the house. But to draw people out, they need attractions: games, activities, conversation pieces, art. An outdoor Ping-Pong table—and an *indoor* hammock. You won't know whether you're coming or going!

Scheme 1 | *Beachtopia*

Dream

The Hamptons in its fifties heyday was crawling with artists. Jackson Pollock, Robert Motherwell, and even Picasso were all hanging out, drinking and pipe smoking on the beach, staring at endless stretches of sky and ocean, bantering about art and architecture and the possibilities of "unframed space." Those were simpler and cooler times. Anything went: Pollock poured paint on the floor, instead of on a canvas. Even starving artists could buy a couple acres of potato field by the ocean for a few thousand bucks and build some wiggy digs. The "action painters" loved visiting one another at their eccentric studios and experimental dwellings—a "pinwheel" house with walls that slide away; or an outdoor solarium with walls and no roof, where you could sunbathe nude in winter. Woohoo!

Reality

The horizon of your backyard may not be endless blue, but it's not a bad plot of green. There's space to do *something*, like an addition that doesn't require building permits. Improvise an "outdoor living room." Find the best shade tree in the yard and that's your spot. Mark the "room" with a red metal frame as if it were the outline of some architectural illusion. Create a hardwood floor by paving the "floor" with concrete, laid in with oak disks. Outfit the space with cute, garage sale furniture and other indoor comforts. A collage of chairs, tables, stools in wood, metal, and in all shapes and sizes. Who cares if you'd never let any of this stuff *inside* your house? Let the critics sniff. The work-in-progress will start to make sense when you paint the whole collection with a few

141

protective coats of the same shade of paint. Title it *Rustoleum Yellow*. So simple, so sublime, so Barnett Newman. Who? You mean you weren't inspired by the minimalist famous for interpreting pure empty space as color with monochrome paintings adorned only with a "zip," or tiny stripe? Throw in a few zippy red cushions made from weather-resistant Sunbrella fabric.

To make the work look expensive, unearth the silver tea service and candlesticks Peggy Guggenheim gave you. Hang tin Moroccan lanterns from the red rafters. All you need now for your artist's lair is some conversation-worthy art. A stretched canvas, so big it might as well be a wall. Call your amateur-artist friends, break out the bikinis and berets, and have everyone paint their best tree. "Action architecture," man.

ALTERNATIVE GUEST HOUSES: A LOT OF BUNK

Sleepover parties, who doesn't love them? But the truth is, while it used to seem cool to see how many people could fit head-to-toe in a single bed, once you're old enough to spell p-r-i-v-a-s-y, it's kind of nice to say good night and be able to ship off the camp friends to separate rooms or, even better, separate houses! Rich people know this. That's why they build guest cottages and "wings." But there are plenty of makeshift lodgings of a more modest scale you can put up on your grounds. Compound the habitable square footage on your compound.

All you need *is a roof, clean sheets, and a catchy name.*

The "Boat-el": Modeled after one of those lakeside lean-tos that artists or fishermen like to build by the shore with just enough room for an easel and a palette, or a few boating supplies. Buy one of those prefab sheds at the hardware store that looks like an oversize dollhouse. Be sure to get one that comes with windows; this isn't supposed to be the prison hot box from *Cool Hand Luke.* Furnish it with a fold-down bunk, as on a cruise ship or a submarine, orange life preserver cushions, lures tacked to the wall for flash, and maybe one of those singing smallmouth bass. Now for the view: Tie a rowboat outside and a big blue rope from tree trunk to tree trunk to make the outline of a wave.

Tree house: In Tim Burton's *Planet of the Apes* remake, his simians lived in Swiss Family Robinson–style apartments that seemed to sprout right out of the tops of trees. Mount a bed on a platform and chain it to the limbs of your best tree.

Y'Awning: Anyone who's hammocked knows the fun of sleep-swinging from trees. Upgrade your hammock situation to overnight status. First step: move away from the tree. Can you really catch eight hours of shut-eye worrying about bird poo and caterpillars? Put up a yellow-striped awning and underneath it set up a freestanding cloth hammock in a coordinating stripe. Pretty. Furnish the "space" with a night table and reading lamp and a pair of outdoor slippers.

Tepee: Even when they've got lots of acreage and cash to burn, people never get over the thrill of the big camping trip in the backyard. Darryl Hannah has a tepee getaway set up in her personal back lot. That's right, just a personal sweat lodge to nap on folded Indian blankets, burn incense, blast Cher's "Half Breed," and recite Navajo poetry. No reservations required.

The Van: When it's a rockin', don't come a knockin'! Pull it out back, and—whoa, nice airbrush sunset—outfit the inside with purple surround-shag and a platform bed. (Make it a seventies-era van. You can get one for a couple hundred bucks and it's the perfect size for a box spring and mattress, after that, they started getting smaller.) Check it out. The white shearling on the bed and seat covers up front look even cooler when we turn the black light on. So does that black velvet Electric Rainbow poster. Between bubble windows are built-in speakers, a CD rack screwed to the wall, groaning with Deep Purple, KISS, Hot Tuna, and Yes.

Guest House a Go-Go

Cynthia: The five-hundred-square-foot surf shack in Montauk was perfect: room for a bed and a board. That was all I needed. Except for one small detail: Where to put the overnight visitors? Rather than build a guest house and deal with permits, construction crews, and plumbers all summer, how much easier would it be to just park an old Airstream trailer in the backyard?

It looked like a beautiful aluminum spaceship. I didn't change the inside: The original paneling and curtains and upholstery were too good. Okay, maybe mustard wouldn't have been my ideal color, but after I scrubbed it down and chiseled off the crud, it was a guest palace that would have made Wally Byam* proud. Paint-by-numbers paintings and some sixties graphic pillows, fun! I laid a flagstone path from the house to the trailer's retractile steps. The sleepover artists loved it.

All right! Ready for more friends! Where to make guest house number two? Of course, the garage!

It was just raw space: unfinished wood frame walls on a slab of cement. We cut in windows and a door. But June rolled around and we were still looking at the brown bags of insulation between the studs. Oh well, drywall seemed too polished anyway. I shortcutted the "renovation" to sweeping, then double stick–taping straw beach mats to the floor. On the studs I hung vintage black-and-white fashion photos. Two Heywood-Wakefield night tables and lamps from my past life kind of worked with the Kerouac crash-pad vibe. I still needed a place to store some real (read "ugly") garage junk, so I hung raw linen curtains to create a breezy false wall. With the curtains, not only do you hide the junk

but you can open the garage door to let in a breeze and no one can see you "mowing the lawn" or "sawing wood" in bed. Now all she needed was a name. We call her "the Bungalow." Not that original, but beats telling your guests they're sleeping in the garage.

✳ **CRIB NOTE**

Wally Byam invented the Airstream, an aluminum trailer with a sleek look inspired by airplane technology, in 1936. We also love him for his favorite expression: "It was impossible, so it took a little longer to accomplish."

Vandalize Your Own Home

Picket-Fence Syndrome: Fear of not blending in doesn't have to mean keeping the front yard like one of those suburban scenes in a David Lynch movie. People want to express themselves. That's why they go kookoo with reindeer at Christmas. But why wait for Santa or the Great Pumpkin? You spend so much time and money and love on the inside of the house, why should the outside have the personality of a dried gourd on a stoop? Shake up the neighborhood in between holidays. Plant a heart of tulips in the front lawn to mark your moving-in anniversary. Tether Apple, your fiberglass palomino, to the split-rail fence for the Kentucky Derby. You'll still be invited to the annual block party, probably. There are plenty of things you can do to mark your turf without the neighbors looking at you like you're one of the Addams family.

147

It's a lucky sign: Gargoyles go on cathedrals to scare away demons. Jews put up a mezuzah, a decorative tube that holds a prayer blessing the house. Adopt a lucky icon for your home. Nail a few horseshoes above the door, open side up so the luck doesn't run out. Hang an Amish hex sign, the wooden plaques Pennsylvania Dutch boys and girls paint on their barns. They have groovy geometric folk symbols said to have magical properties: a heart for love, the distelfink (a cute bird) for good luck and happiness. Aristocrats, who don't really need luck because they have titles and money, have their family crest mounted at the entrance. Look up yours, or invent one. Our crazy professor friend Tomás in Barcelona invented a symbol that he had tiled on the outside of his house: a question mark punctuated by an infinity sign. Who knows what tomorrow will bring? Olé!

Cynthia:
What's Irish and sits on the front lawn?

Answer: Patty O'Furniture

Raise the stars and stripes: And since it's your castle, what about your own family banner? Your coat of arms doesn't have to be lions and serpents. A flag is just a piece of fabric, after all. Make yours the clan's tartan plaid, or borrow our salute: stripes! What else? Keep on hand a few special-occasion flags for visiting dignitaries: the red-and-white Maple Leaf flag for your Torontonian boyfriend's annual Canada Day party. Well, it's cooler than tying balloons to the mailbox.

Change your shade: "It's the white house with the black shutters," you hear yourself say every time someone's coming to visit. The color scheme doesn't have to last until you've paid off the thirty-year mortgage. If the windows are the eyes of the house, consider the shutters the eye shadow, a place to dabble with bold color. No big whoop. Painting the whole villa pink could be scary—

> ★ ★ ★ ★
>
> *Ask Swelloise*
>
> ***How to fold a flag:*** *Not like a bath towel. It's a ritual with its own rules and regulations, and is supposed to end in a neat triangle reminiscent of our forefathers' tricorner hats. Grab a partner. Each of you take the short end of the flag. Always hold it parallel to the ground but never let it touch the ground—that's taboo and you'll be court-martialed. Fold the flag widthwise so the stripes cover the side with the "union" on it. Then holding the flag striped side up, repeat the widthwise fold. The union is now folded in half, facing both up and down. Now, starting at the folded side of the striped end, fold the flag into a series of triangles, switching corners with each fold until just a blue square of the union is peeking out from the triangular fold. Take the corner on the open leg and fold it down along the edge of the other leg to form a triangle. Then tuck the remaining blue tab under the folds of the thick triangle until the flag is a neat triangle and can't easily unravel. At ease.*

even if it is the color of your favorite hotel in Barbados. But a smidge of Caribbean pastels—lemon tree yellow, key lime—on the front steps, the garage, the shutters could change your worldview, at least from the driveway. And come to think of it, how come those shutters never actually open or shut? If they're just decorative, take them off and put up something more so: billowy linen drapes or cafe curtains—in outdoor fabrics, of course.

Paint the lawn: White paint used to mark up ball fields can also be used to distract from the crab grass. Draw the world's biggest welcome mat on the front lawn. Say what you like, it'll be gone next time you mow.

Over Hangover

Ilene: *In some states it's illegal to have indoor furniture on the front porch. Well, live dangerously, I say. At my weekend house, we don't exactly have a front porch. It's more like a cement stoop with an overhang. Just a place for muddy shoes. I proposed to my boyfriend, Rick, that we upgrade it to a porch with chairs and a table. That way, if we were expecting guests but running late, we could set out welcome drinks like they do at good hotels. Nice! "Maybe we should also put the car on cinderblocks," he suggested helpfully, "and get some rusted car parts to use as lawn ornaments." He shamed me out of the idea. But then one summer night's party, I discovered smokers squatting on the cement steps puffing away. Now that's tacky. I dragged around a pair of vintage patio chairs—white metal with olive plastic string seats—that couldn't look tacky anywhere, and nailed a flower still life right into the shingles. Rick said nothing until the next day when we were killing time till the roofer came with an estimate, or something. "Why don't we sit out front and look through our shingle catalogue while we wait?" he said. We looked like Ma and Pa Kettle. Now all we need are a few mangy hounds barking under our feet.*

Scheme 2 | The Last Resort

Dream

On the rolling lawns of Gold Coast country houses, Gatsby types are always cavorting on grass courts, rare pony stables, nine-hole golf courses—as much action as they can pack into every inch of acreage. A home is, after all, as Zelda Fitzgerald once said, "a place to do the things you want to do." But tennis and croquet aren't the only games in town. So, add some leisure class to your grounds with games that require minimal upkeep. (Not that we have anything against hiring pool boys.) The swell country club has lots of spectator seating, courtside cafe service, and extra towels. Here, the keys to the clubhouse.

Reality

La Bocce Vita: The dolce-vita version of lawn bowling is a game played by little old men named Dom. It has two objectives: to throw the ball closer to the *pallino,* or target ball, than your opponents, and to drink lots and lotsa *vino.* You got a problem with that? All you need is a very long sandbox. Thirty yards is regulation length, but you can have the carpenter build the frame box about half that size. You got a problem with *that?* Pick up a baby grape arbor at the nursery to go alongside. Now that's a-beautiful a-spot for your *barreria.* That's a row of cafe tables with slatted folding chairs and standing wine buckets. Red-checked tablecloths so classic you could have a pair of capri pants made out of one. Put on some cork sandals and dark glasses and you're in uniform. Join your teammates on the bench: *mangia* focaccia sandwiches, comment noisily on the game, and cheer, "*Brava*" and "*Cin cin!*"

151

Darchery! On the other side of the vines, gather ye merry band for a few rounds of archery, or "darchery," as we call this hybrid game that involves darts instead of full-fledged bows and arrows (which take a lot of room unless you live in King John's castle and have a lot of peasants to run around pulling the arrows out of other peasants' arses). Prop up your target against a stack of hay bales to catch stray arrows, oops, darts. Stick an apple into the bulls-eye with a real arrow (props to William Tell). On the neighboring oak tree goes a peg holding a feathered Robin Hood cap that each markswoman must don before drawing her dart. At a safe distance behind the "darcher," line up extra bales of straw strewn with cushions in bright, heraldic colors to soften the seats for the Maid Marions and Merry Men in tights waiting their turns.

!Mira! El Checkers: The shady end of your private park is just the spot for whiling away the hours with contemplative pursuits. Play mind games: chess, checkers, dominoes. Only in your cerebral playground all the places aren't taken by old Dominican men in guayabera shirts. Lay a checkerboard patio with black-and-white linoleum squares, like they have at the Delano Hotel in Miami, and a few cement tables from the garden supply store, and paint the tops with a checkerboard pattern or backgammon triangles. Mount the biggest clock you can find on the side of the house—with a second hand—to keep your opponents moving in under two minutes. Very *Alice in Wonderland*.

Table Tennis Anyone? Who needs a clay court when there's outdoor Ping-Pong! Make it baby Wimbledon, baby! Concealed by a few feet of privacy hedge is the table, a set of bleachers, and white terry seat cushions. A high-chair for the linesman on the other side. Ice buckets of Gatorade and other endorsed beverages. Visors for everyone! And lots of ball boys, of course.

TAMING THE URBAN OUTBACK

In the city, if you've got a terrace, a roof, a fire escape, or any outdoor space, the lanai concept still applies. Make it an extension of the indoors, even if it's as simple as putting something good-looking there that will draw the eye out. Or, continue the color scheme. If it's a pink area rug in the living room, extend the feeling of floor space by painting the inside of the balcony the same shade.

Scheme 3 | *Urban Sandbox*

Dream

"Oh, and it has a terrace!" That old selling point hooked you on this otherwise utterly average one-BR, didn't it? "It's practically an extra room," the broker said. "A breakfast nook!" "It could be an outdoor office!"

Reality

Hah! You *never* go out there. And why would you? Even up on the sixth floor, it feels like you're in the middle of the street, toking on a tail pipe. Little wonder it inevitably turns into a soot locker for old bicycle tires, moldering children's toys, a couple of plastic chairs from the grocery store.

Step 1: Make sure nobody's down below, and throw those diesel-dusted basil pots over the ledge. Your terrace is never going to be an organic farm, a nature preserve, or a hangout. The charm of the average terrace isn't actually *being* outdoors, it's having the feeling of *seeing* the outdoors while you're tucked safely inside your climate-controlled, noiseproof refuge. Think of it as an optical extension. Fake, yes. But one that can give the illusion of added length and glamour to your apartment.

For a party in the dead of January, Denise Rich, the songwriting socialite, iced her wraparound terrace and hired professional skaters to glide past the windows for the partiers' amusement. Ice is always nice, but, alas, now been done. There's got to be a simpler way to attract the attention of your jet set who see the Upper West Side as their international...*playground.* That's *brill.* Fill the terrace with sand—make it pink sand, ordered from a playground supply company. Everyone will assume it's imported from Bermuda.

Put up two fake palm trees and—are you sitting?—a leaping dolphin sculpture made of reinforced concrete. No? How about the seal sunning himself? *Fun*tastic. And off to the side, the plastic ball he'd tired of spinning on his nose. Lazy rascal.

My Backyard's in Turnaround:
The Making of the Rooftop Theater

Cynthia: *The main attraction of my apartment downtown was that it came with a roof deck. The only drawback was the view. They have better ones in cellblock eight. Then I looked at the cinder blocks and thought of the perfect crime. But that's another story for another day. I also saw a perfect wall for projecting movies. I splurged on a projector and rolled all the equipment in and out of the house on one of those AV carts geeky high school teachers love. To give the "screening room" some movie-*

palace special effects, I raised the terrace about eight inches with a wooden frame that holds perforated metal grates. Underneath the grates are outdoor colored lights. A mysterious glow comes through the holes. I keep aluminum lounge chairs out there, lined up in rows like on a ship's deck, and on starry movie nights I pass out the popcorn and the Twizzlers. There is a small glitch: The holes in the grates are about an inch in diameter—just big enough for the movie premiere guests' high heels to fall through. I'm still working on that one.

4 New Uses For... *Your Terrace*

❖ **STORING LAWN ORNAMENTS:** Start a plastic menagerie: deer in summer, penguins in winter. Lots of elves. ❖ **A NIGHT-LIGHT:** On outside, off inside. ❖ **A STUDIO:** Put out an easel with a painting "in progress." Change the gallery from flower still life in spring to sailboats in summer. Leave out some brushes in a can like maybe you're painting it, maybe you aren't. ❖ **CREATE THE AURA OF POPULARITY:** Set up mannequins in vignettes.

MAKE YOUR GARDEN GLOW

Funny how the same outdoorsy stuff you do during the day can seem so much more romantic after dark. Night skiing. A midnight romp on the beach. An après-dinner stroll through the Tuilleries in Paris. Ah Paris. Beautiful any time of day, but at night she becomes the City of Lights! Overflowing with magically lit backdrops, she is designed for insomniac promenades on bridges, boulevards, past glowing monuments. All—how do you say?—flaws are hidden. Put some ooh-la-lighting in your own backyard.

Moon-shine: This creates the effect of moonlight, only on a dimmer! If you have a large tree, put floodlights in it as high as possible. Downlighting, as the pros call it, creates a general luminescence ideal for entertaining on the deck, or scampering on the lawn. Use at least two fixtures in each tree, aimed so the light beams cross, illuminating any interesting branches or areas nearby. But keep them hidden: The key to making lunar luminescence seem as natural as possible is to conceal the fixture, so you don't see the source.

Spotlights, shadows, and silhouettes: For something you want to show off, like a statue, a neat tree, or the swirling snow, light it from below. Uplighting, as you might have guessed, is rarely seen in nature and so has a slightly unnatural or stage-set feel. To silhouette, say, a stone near a wall, place the light in the ground directly *behind* the object. For a shadow effect, place the light *in front* of the object aiming up through it at the wall.

Ambient light: If you spotlight or moonlight everything, it'll be as bright as a prison yard after a jail break. The areas in between get fill light, a dim light that contrasts against the brighter lighting. A typical for instance would be low-wattage lights lining a path. Focal areas should be about ten times as strong as fill lights.

Light at the end of the tunnel: Illuminating plantings at the back of the garden provides background light and perspective. To make a garden look bigger, dim lights in the foreground and along a path that has a brighter light at the end.

Who Says You Can't...Hang a Chandelier from a Tree?

Generally, people assume outdoor lighting is limited to officially designated outdoor lighting fixtures. But the truth is, an outdoor fixture doesn't need the official label, it just needs a seal of approval from an electrician. Almost any light fixture can be wired for outdoor use by a lamp doctor or electrician. Then you can amuse yourself for hours, watching the squirrels swinging from the chandelier.

Scheme 4 | *The Accidental Tourist Spot*

Dream

The cool roadside bar you discover when you leave the hotel for a day trip to "the other side of the island." The mates park their mokes at this dive oasis and bare-belly up to the bar for an afternoon of jerk punch and rum chicken. Coconuts clink. Everyone's feeling "irie" and before you know it, the sky is turning pink and melting into the sea. "Day-o, daaay-o, daylight come and me never want to go home."

Reality

Put the bar back in bar-becue, mon! Build your own off-the-beaten-path tourist dive. First, find yourself a "found object." Those island bars always appear to have popped up spontaneously from some abandoned piece of wreckage: an airplane wing, a hunk of driftwood, a chicken coop. What luck, an old long board! That'll do. For legs, get four three-inch black pipes (that's the width, not the length) from a plumbing supply store, attach them to the underside of the board with flanges, threaded caps you screw into the board that the pipes fit into. Another set of flanges on the ends of the pipe legs will keep them from sinking into the ground. And while you're under there, attach a rack for glasses to the bottom of the board, too.

Plant a tuft of ornamental grass on either side of the surf bar. They look like the dunes, and grow fast and big—big enough to hide a cooler loaded with ice and uncolas on one side, a boom box on the other. *"Put dee lime in dee coconut, and drink it all up."* Define the limbo zone with conch shells and tiki torches outlining the shape of a lagoon. Fill it with the blue pebbles they use in fish tanks. Underneath the board goes a set of mix-match bar stools that brother Ziggy "found" behind the ol' hotel, or that you found at yard sales. Allrighty, put out a tray with a pitcher of the house special drink. "What's your hurry, mon? Forget to sex-wax de board before setting down de drinks? They slip off!" *"Sun is shining, the weather is sweet, yeah. Make you wanna move your dancing feet."*

The Floating Table

Cynthia: My country house in Upstate New York was really country. Sometimes I felt like Eva Gabor on Green Acres. The house was perched high with a stone terrace overlooking the woods, lots of big rocks, even a tiny lake. I might as well have been living in a state park. But for dining on the patio, I didn't want ye olde redwood picnic table. Better something you might have discovered at the top of a hike— the ruins of a foundation that just happens to sit right under a big shade tree.

The premise: a stone oval creation with a hollowed-out center you could fill with water, and a drain at the bottom. I put a slate ledge around the top, about eighteen inches— just wide enough to hold a dinner plate and a wineglass. For seating, ottomans made out of thirty-gallon drums, cut in half and then perforated so the holes formed little constellations. (The thinking was you could put a candle underneath each seat and at night it would beam Little Dippers and Orions.) For the top of each stool, I made seat cushions from foam pillows, covered in embroidered velvet for fall, and in souvenir scarves for summer. Before guests would arrive, I'd take a hose and fill the center with water, then "set the table" with teak bowls which float. Guests sail the grilled shrimp to one another.

Scheme 5 | The Desert Inn

Dream

Palm Springs, circa the Rat Pack. There's no better place we can think of to illustrate classic swell style: inventive, glamorous, unpretentious, and designed for high-octane swinging society. This Shangri-la of date palms and fuchsia bougainvillea between pink-and-yellow mountains was an oasis of cool, where the air was as dry as the martinis.

This idea of cosmopolitan country living attracted all kinds of Hollywood glitterati: Lucille Ball, Cary Grant, Clark Gable, assorted Gabors. They came to swing, at golf clubs by day and nightclubs by night. Their houses were built to party. Equipped with a pool and a piano. To get the gang goofy, Walt Disney invited guests for overnight horseback rides into the canyons complete with chuck wagon dinners.

After World War II, this desert playground was a hotbed of young architects hopped up on new modern theory, itching for anything experimental and rule-breaking. New technologies allowed them to use glass and steel to merge landscape and architecture into a seamless whole. To them, "country" did not mean a bucolic barn or farmhouse, but a house that blended into the countryside. To bring Nature indoors, they built seemingly transparent, weightless houses directly into the mountains, often leaving rocks and boulders right where they were to serve as a room divider, or just "sculpture."

When he made his first million, Frank Sinatra wanted to build a great getaway in Palm Springs. He had his sights set on a white brick Georgian house. The architects talked him into a plan better suited to the desert landscape. Soon enough, Sinatra got into the groove and was ordering up a heated swimming pool in the shape of a grand piano.

163

Twin Palms, the place is called. At high noon, the sun casts a shadow in the form of piano keys on the terrazzo. A single motorized sliding glass door opened the entire living area to the pool. At sunset, he would raise a flag to announce 'tini time.

Reality

Womb chairs and egg chairs, Eames and Nelson. These days it's hard to imagine how to do midcentury modern without seeming like a designer diorama out of *Wallpaper* magazine. It's all become so serious and designy. Don't touch that bird! It's an Oiva Toikka!

But that's not what modernism is really about. What made those modern homes was that they were designed to be both functional and fun. Leather and steel and plastic were practical: kids could spill all over it. And there was plenty of cool stuff that didn't come with a legendary label. Likewise, you don't need an original grasshopper or ox chair (even the names were fun), you need the philosophy behind it—streamlined comfort, experimentalism, and irrevererence in your oasis.

Bring some desert bloom into your living room—first must is a pool: a kidney-shaped blue rug and a glass coffee table to catch reflections. Cut a winding path into the hardwood floor and fill it with gravel, have it lead in one door and straight out the back. Paint the wall yellow and hang sun clocks. Get a boulder, the biggest one you can roll into the living room. If the rock's too heavy and the door too narrow, try a giant cactus plant in the corner. A pair of bougainvillea-print chaise lounges and a wicker hanging chair that you hung yourself. Underneath it a strip of green area rug with a putting machine at one end. Now you've got that swing!

164

SO BAD IT'S GOOD:
Indoor Plants

The celery of the home. Indoor plants have become varietals of generica. Peace lilies in black office planters. Macramé hanging baskets from some seventies fern bar. Some people talk to their plants, but do they listen when the plant talks back? "Get me out of this pot! I've been stuck in the same dirt for five years! I'm fossilizing!" Liberate them from their leafy green ghetto. Reseed. Maybe the problem isn't the plants but the planters. We didn't have any good ideas for this one, but at least we've narrowed down the problem.

ell, that concludes our Swell house tour. We hope you had a few laughs, learned a useful thing or two, and saw a couple of things you might like to try at home. But it won't hurt our feelings one bit if, when you put down this book, all you can think of is how you could do things better yourself.

Hey, we're not experts. And we certainly didn't set out to create a showcase that will give you a crippling case of couch envy. We don't have all the answers. Cynthia's sleeping in a bedroom with a third of a wall covered in wallpaper she regretted as soon as she unrolled it. Ilene's is no better: a jumble of boyish plaids that look like they belong in a cub scout's bedroom.

No Swell home is perfect. But it's your creative castle. So, time to start your dream pad file, filled with inspirations—movie stills, swatches, Polaroids, postcards, a page torn out of a magazine, or even this book! Now whip out your can of Jungle Red paint, put on your highest high heels (good for the hard-to-reach places), and START ROLLING!

Sources

THE FOLLOWING BOOKS HELPED OUR RESEARCH FOR *Home Swell Home...*

The Bed and Bath Book, Terence Conran, Crown Publishers, Inc.,
New York, 1978

Better Homes and Gardens Decorating Book, Meredith Publishing, 1956

Confessions of a Window Dresser, Simon Doonan, Viking Studio, 1998

Decoration U.S.A., Jose Wilson and Arthur Leaman, Macmillan Company,
New York, 1965

Designing and Installing Outdoor Lighting, Grolier, 1987

Home: The Twentieth Century House, Watson Guptill Publications, 1999

House & Garden's New Complete Guide to Interior Decoration, Fifth Edition,
Simon and Schuster, New York, 1953

Legendary Decorators of the Twentieth Century, Mark Hampton, Doubleday,
New York, 1992

Living in Style, Marco Pasanella, Simon and Schuster, 2000

Mediterranean Living, Lisa Lovatt-Smith, Watson Guptill Publications, 1998

Modern Painting, Hugh Adams, Mayflower Books, 1979

The Modern Interior, St. Martin's Press, 1964

Practically Minimal: Simply Beautiful Solutions for Modern Living, Maggie Toy, Thames & Hudson, 2000

The Shock of the New: Art and the Century of Change, Robert Hughes, British Broadcasting Corporation, 1980

Underground Interiors: Decorating for Alternative Lifestyles, Norma Skurka, Galahad Books, Quadrangle Books, New York, 1972

Retail Design, Otto Riewoldt, teNeuse Publsihing, New York, 2000

Verner Panton: The Collected Works, Vitra Design Museum, 2000

Weekend Utopia: Modern Living in the Hamptons, Alastair Gordon, Princeton Architectural Press, 2001

Dream Pad File